P9-DFW-751

EYEWITNESS ART

MANET

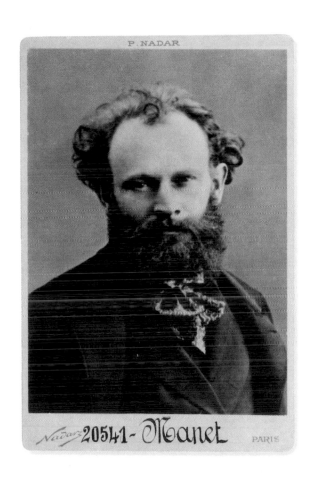

P. NADAR

Nadar 20541 - Manet PARIS

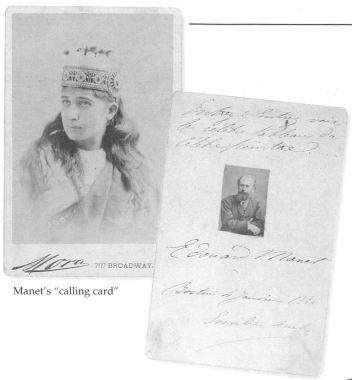

Manet's "calling card"

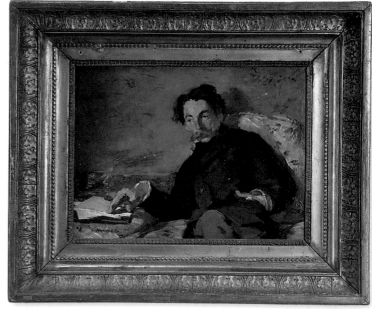

Portrait of Stéphane Mallarmé, 1876

Emile Zola's booklet
defending Manet's art

Hand-painted
tambourine

Poster for the
Ambassadeurs theater

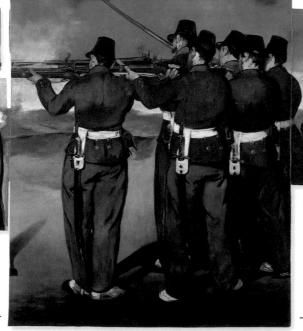

*The Execution of
Emperor Maximilian,
1867–68*

The Barricade

EYEWITNESS ◉ ART

MANET

PATRICIA WRIGHT

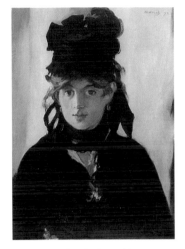

*Berthe Morisot with a
Bunch of Violets,* 1872

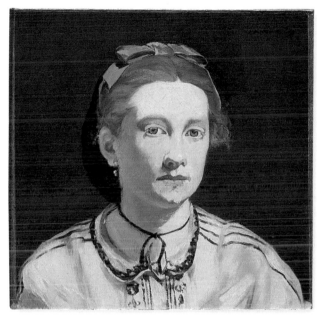

Portrait of Victorine Meurent, 1862

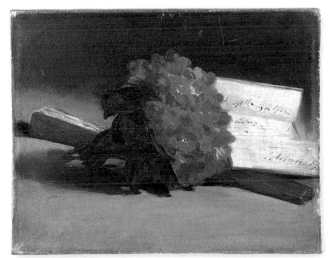

Violets

Letter from Victorine
Meurent to Madame Manet

Bouquet of Violets, 1872

DORLING KINDERSLEY
LONDON • NEW YORK • STUTTGART
IN ASSOCIATION WITH
NATIONAL GALLERY PUBLICATIONS, LONDON

Portable
paint box

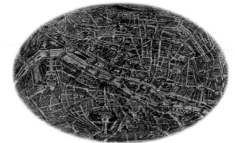

Map of Paris

Japanese courtesan

A DORLING KINDERSLEY BOOK

To the memory of my father, John L. Wright

Editor Phil Hunt
Art editor Mark Johnson Davies
Assistant editor Louise Candlish
Assistant designer Simon Murrell
Senior editor Gwen Edmonds
Senior art editor Toni Rann
Managing editor Sean Moore
Managing art editor Tina Vaughan
U.S. editor Laaren Brown
Picture researcher Julia Harris-Voss
DTP designer Doug Miller
Production controller Meryl Silbert

First American edition, 1993
2 4 6 8 10 9 7 5 3 1

First published in the United States by
Dorling Kindersley, Inc., 232 Madison Avenue
New York, New York 10016

Copyright © 1993 Dorling Kindersley Limited, London
Text copyright © 1993 Patricia Wright

All rights reserved under International and Pan-American Copyright
Conventions. No part of this publication may be reproduced, stored in
a retrieval system, or transmitted in any form or by any means,
electronic, mechanical, photocopying, recording, or otherwise, without
the prior written permission of the copyright owner. Published in
Great Britain by Dorling Kindersley Limited.
Distributed by Houghton Mifflin Company, Boston.

Library of Congress Cataloging-in-Publication Data
Wright, Patricia.
 Manet / by Patricia Wright. -- 1st American ed.
 p. cm. -- (Eyewitness art)
 Includes index.
 ISBN 1-56458-172-1
 1. Manet, Edouard, 1832-1883. 2. Painters--France--Biography.
I. Title. II. Series.
ND553.M3W75 1993
759.4--dc20
[B] 92-54546
 CIP

Color reproduction by GRB Editrice s.r.l.
Printed in Italy by A. Mondadori Editore, Verona

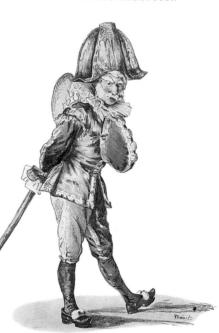

Manet's funeral book

Polichinelle, 1874

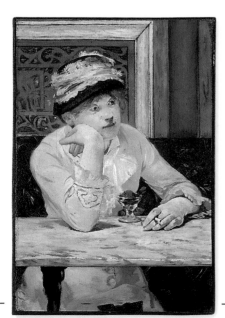

The Plum,
1878

Plum
glass

Palette
used as a
shop sign

Contents

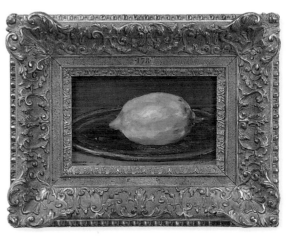

The Lemon, 1881

The headstrong youth

MANET'S BIRTHPLACE
9 rue des Petits-Augustine
(now rue Bonaparte),
opposite the Louvre, Paris.

EDOUARD MANET WAS NO child prodigy. He was born on January 23, 1832, into the comfortable world of his wealthy bourgeois parents, Auguste and Eugenie-Desirée Manet, and his childhood years passed uneventfully.

When Edouard announced his ambition to be an artist, his father was reluctant, suggesting instead a naval career. At the age of 16, Edouard embarked on a six-month voyage to Rio de Janeiro, but, contrary to his father's hopes, the voyage served only to strengthen his resolve. On his return, Manet's career as a painter began. In 1850 he registered as a copyist in the Louvre (pp. 8–9) and as a student at Thomas Couture's studio (pp. 10–11).

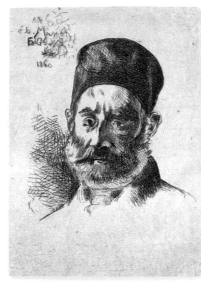

PORTRAIT OF M. MANET PERE
Auguste Manet was a high-ranking civil servant who became a judge of the Court of First Instance at the Seine. This is the earliest of Manet's portraits of his father, an etching that he made in 1860.

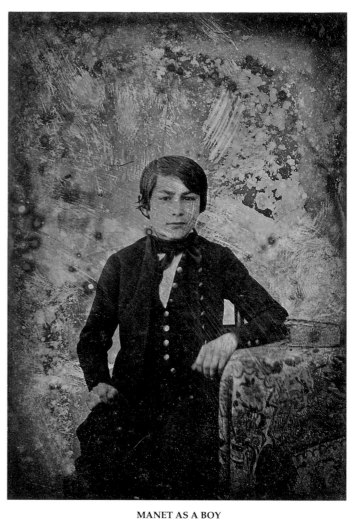

MANET AS A BOY
Manet seems to have been a happy, well-balanced child, with an affectionate relationship with his family and a pronounced dislike for scholarly activities. At school (where he had to stay on for an extra year) he revealed no particular aptitude or inclination to study. His talent for drawing, however, had manifested itself early, and it soon became clear that Edouard would not follow in his father's footsteps and enter the legal profession.

EARLY LIFE IN PARIS
Manet started school at the age of six at Abbé Poiloup's at Vaurigard. His education continued at the Collège Rollin, a boarding school for sons of the wealthy, which he entered at the age of 12, and it was there that he first became friends with Antonin Proust (p. 49). Soon after, his family moved to rue Mont-Thabor, near the Tuileries Gardens.

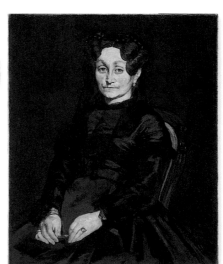

PORTRAIT OF MME. MANET MERE
1863; 41¼ x 31½ in (105 x 80 cm)
In this rather austere portrait of his mother in deep mourning, painted shortly after his father's death in 1862 (pp. 26–27), Manet pays tribute to her strength of character. She was a moral as well as financial support to Manet throughout his life. His earliest letters reveal a warmth toward his parents that is not always apparent in his paintings of them (p. 48).

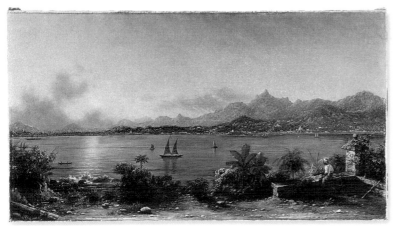

THE HARBOR AT RIO
Martin Johnson Head; 1864;
18¾ x 33⅜ in (46.7 x 84.7 cm)
This painting of Rio de Janeiro conveys the exotic landscape that awaited Manet. In his letters home, he described the carnival at Rio, in particular the Brazilian ladies "... on their balconies, bombarding every gentleman who passes with multicolored wax balls filled with water." It was an enduring image which would recur much later (pp. 46–47).

SHIP'S COMPASS
Edouard failed his naval entrance exam twice, but could have joined after completing a trial voyage.

THE STEAMER
1864; 5¾ x 7¼ in (14.3 x 18.5 cm); graphite and watercolor
On the whole, Manet found the sailor's life very dull: "Nothing but sea and sky, always the same things, it's stupid." During the long empty hours he produced drawings and watercolors of ships, committing to memory his observations for later works, such as this watercolor (right), which he made in a sketchbook nearly 20 years later.

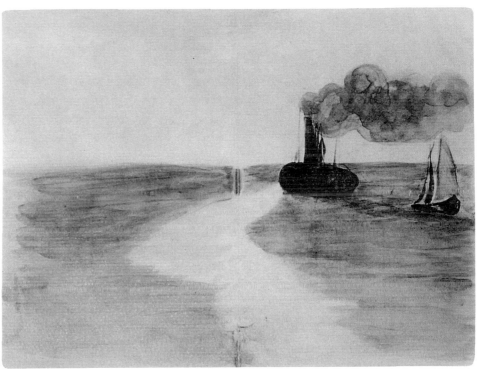

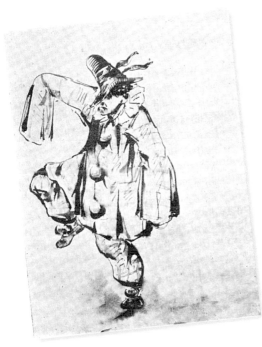

PIERROT IVRE
c.1849; watercolor and pen; specification not available
Manet gained a reputation for his talent for caricature and drew several of his shipmates (left). His first "commission," to retouch the damaged colored rind on the ship's cargo of cheeses, caused an outbreak of lead poisoning in Brazil.

ANOTHER WORLD
Rio de Janeiro (below), as it appeared to Manet in 1848. In a letter to his mother, he recounted seeing a slave market, which he described as "a rather revolting spectacle for people like us."

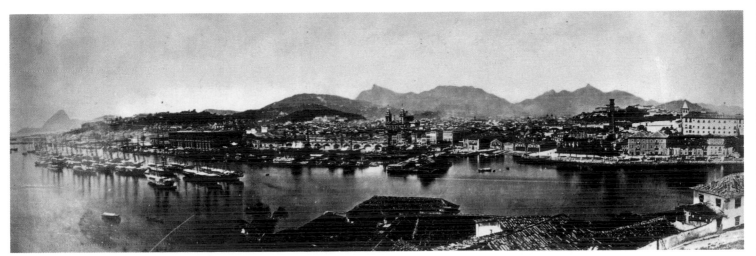

Copying the masters

ART SUPPLIERS
Le rapin ("the rat") was a common nickname for the painter's apprentice or young student. It was common practice for artist's palettes to be used as shop signs. Here we can see the "rat" dressed in a suit and soft hat, presumably off to work with a portfolio and easel.

MAKING DIRECT AND THOROUGH copies in front of the old masters was regarded as an essential part of a young painter's training. A typical day for an art student in the 1850s would begin with the morning spent drawing from plaster casts or life models; the afternoon would be spent copying from masterworks hanging in the Louvre. As a student, Manet also made trips abroad in order to study and make copies from paintings – in 1852 and 1853, he visited Holland and Italy, returning to Italy in 1857, when he copied Titian's *Venus of Urbino*. From the very beginning Manet drew inspiration from the old masters, and he made no secret of his debts to them. They provided him with models for some of his greatest paintings – models for which he created completely new, sometimes openly irreverent, and thoroughly modern settings (pp. 24–25, 28–29, and 38–39).

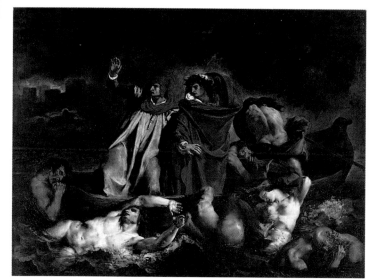

THE BARQUE OF DANTE
Eugène Delacroix; 1822;
74½ x 96¾ in (189 x 246 cm)
Delacroix was the undisputed leader of the Romantic school and arguably the greatest French painter of the first half of the 19th century. From an aristocratic background, he entered into the studio of a distinguished Neo-Classicist, but soon met, and was profoundly influenced by, the remarkable Théodore Géricault. His famous painting *The Raft of the Medusa* (1819) hung in the Louvre and was the inspiration for this painting.

DELACROIX'S STUDIO
This engraving by Best shows the studio Delacroix took in the Place de Furstemberg following his commission to decorate a chapel in a nearby church.

VENUS OF URBINO
(AFTER TITIAN)
1857; 46¾ x 65 in (119 x 165 cm)
This small copy (right) of Titian's *Venus of Urbino* (1538) is one of a group of copies Manet made at the very beginning of his career. The majority of Manet's earliest paintings are, in fact, copies of works by the old masters, and he made this one while on a trip to Italy in the autumn of 1857. This naked Venus was the most enduring image he brought home with him, as we can see from her metamorphosis into a very different kind of Venus, *Olympia*, six years later (pp. 28–29).

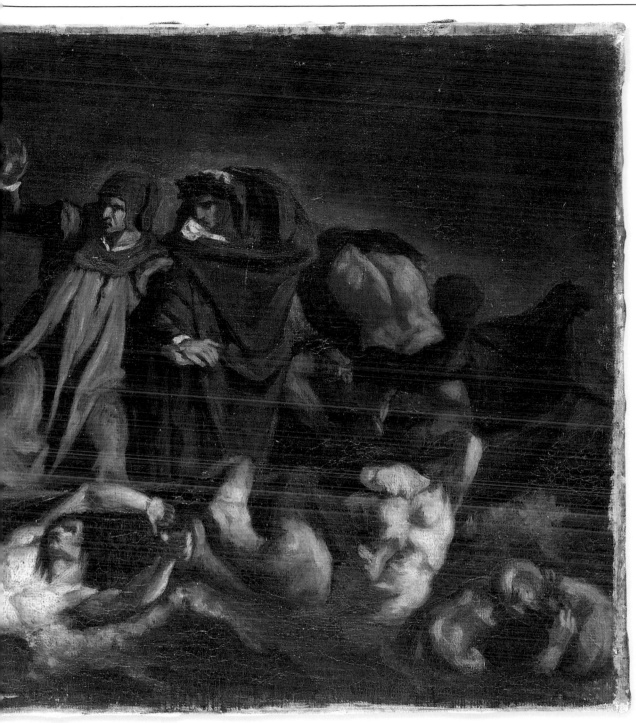

🖌 **CAREFUL COPY**
Manet made at least two copies of Delacroix's *The Barque of Dante*. This is thought to be the first version, executed with careful attention to detail. Another version, done around the same time, is more of a loose sketch.

🖌 **SUBDUED COLOR**
Although a faithful copy, Manet's painting is more subdued than the original; it is a closer-toned work, dominated by a range of browns. All that remains of Delacroix's passages of striking color is the rich red cowl worn by the figure of Virgil.

🖌 **COUTURE'S INFLUENCE**
When Manet made this copy, he was Couture's student (pp. 10–11). The visible concern for overall harmony of color and tone here exhibited by Manet may well have been a direct result of his teacher's instruction.

🖌 **DORMANT COLOR**
Many years later, the unusual color range of Delacroix's *Barque of Dante* appears again, revitalized in Manet's "beggar-philosopher" series (pp. 38–39). The strong colors of red, brown, and blue re-appear in the form of the beggar's hat, cloak, and tunic, this time with an intensity of hue to match the original.

The Barque of Dante (after Delacroix)

c.1858; 13 x 16¼ in (33 x 41 cm)

Delacroix was a highly respected artist but had a reputation for being cold and unapproachable. To make copies of his magnificent *Barque of Dante*, Manet and fellow student Antonin Proust visited him to ask his permission in person. They were received with great courtesy, if not great warmth, and Proust later recalled Manet saying, "It's not Delacroix who is cold; his theories are glacial." When Manet's art was being criticized, Delacroix, too old and ill to help influence the Salon jury, is reputed to have said, "I wish I had been able to defend that man."

COPYISTS IN THE LOUVRE
By the end of five years as a student, it was expected that the young artist would have developed a firm grasp of the old masters' techniques. These would then be applied to their own paintings, thereby perpetuating the same stylistic devices. In this engraving, the young woman (far left) is engaged in a copy of Tintoretto's *Self-Portrait*, which Manet also copied in 1855.

Manet as student

IN JANUARY 1850 MANET, together with his old school friend Antonin Proust, became one of approximately 30 students under Thomas Couture's tutelage. Couture had set himself apart from the established *Ecoles* ("Art Academies"), taking no part in their system of competitions, medals, and prizes. Though he did place great emphasis on classical composition, Couture valued spontaneity and freshness, and steered his students away from the academic obsession with detail. Even so, there were frequent disagreements between Manet and his tutor, and their personalities clashed on many occasions. Manet rejected much of Couture's formal teaching, and Couture, in return, attempted to undermine his rebellious student. But Couture did influence Manet's art, and Manet must have known this at the time; he remained Couture's student for six years.

"THE RAT"
This cartoon depicts a *"rapin"* (p. 8), here used as a derogatory name for an older student who lacked ability.

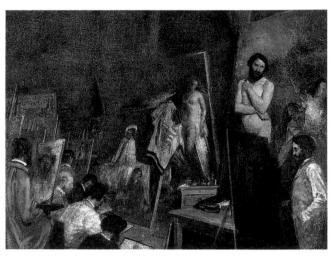

THE STUDIO OF THOMAS COUTURE
Anonymous; 1854–55; 18 x 24 in (46 x 61 cm)
Thomas Couture held a romantic view of the artist as an isolated genius, and it was largely because of this, and his independent stance, that he was popular with young artists.

Romans of the Decadence

Thomas Couture; 1847;
183½ x 305 in (466 x 775 cm)
This was the painting that established Thomas Couture as a successful independent artist. He exhibited it at the 1847 Salon and set up his *atelier* (studio) shortly afterward. The significance of this painting in relation to Manet lies in the number of pictorial sources he used; he borrows from Titian, Rubens, and Marcantonio Raimondi (p. 24). In the manifesto outlining his artistic beliefs, Couture stressed the importance of "Study[ing] all the schools to reproduce the wonders of nature and the ideals of our time in a noble and elevated style."

EARLY REPUBLICAN LEANINGS

The years Manet spent as a student in Paris were politically turbulent ones. Following Louis Napoleon's *coup d'état* in December 1851, federal troops were sent in to quash the Republican-led opposition – resulting in the "Massacre of the Boulevards." Manet and Proust ventured out into the midst of the rioting. They were arrested and spent the night in a police station.

HEAD OF A BOY

c.1850; 14½ x 11¼ in (37 x 30 cm); pastel on paper

This delicate drawing was done in Manet's first year at Couture's studio. It is noticeably more restrained than later works, and displays a concern for careful and systematic build-up of form.

AN EBAUCHE PALETTE

In every student's training, great emphasis was given to the *ébauche* – or underpainting of a painting. Students were taught to render, quickly and freely, composition, light and shade, and simplified color before moving on to the tightly controlled finishing stages. Unlike his contemporaries, Couture was known to allow *ébauche* elements to show in his finished painting.

ENROLLMENT FEE RECEIPT

Couture had become disillusioned early on by the Academic system of trials and competitions, and looked elsewhere for patronage. His great success at the Salon of 1847 enabled him to open his own atelier the same year. His classes contained between 25 and 35 students, who were each charged a yearly fee of 120 francs.

This note is Couture's handwritten receipt for a fee paid by Manet in 1856.

The first rejection

AFTER LEAVING COUTURE'S establishment in 1856, Manet set up a studio in the rue Laboisier. It was here that he painted *The Absinthe Drinker*, his first submission to the Salon, and his first rejection. This disappointment marked the beginning of Manet's lifelong quest for recognition through and from the Paris Salons. Throughout his career he met with slander and ridicule, and he achieved considerable notoriety. Couture was harshly critical of *The Absinthe Drinker* and, as a member of the jury, probably instrumental in its rejection from that year's Salon. At that time the Salon was virtually the only real opportunity available to artists to show their work; the few private galleries that there were in Paris rarely mounted exhibitions, and no other artists' forum existed.

LITERARY FRIEND
Manet met the poet Charles Baudelaire in 1858. Though Baudelaire was 11 years Manet's senior, they became good friends and enjoyed a mutually inspirational relationship. Baudelaire had entered the public eye when his *Les Fleurs du Mal* was banned in 1857 and he faced charges of offending public morality. Like Manet, he was a *flâneur* (pp. 14–15) and a leading member of the Paris avant–garde.

ABSINTHE LABELS
Absinthe was a powerful, and highly addictive hallucinogenic liqueur. It acted on the nerve centers, rapidly inducing intoxication and delirium, and was thought to cause madness.

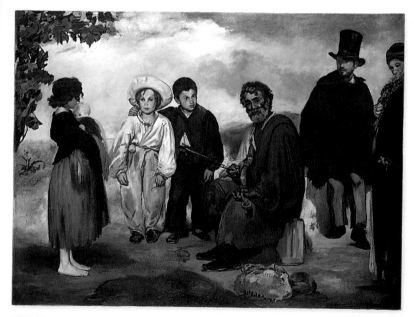

THE OLD MUSICIAN
1862; 73½ x 97½ in (187 x 248 cm)
Manet's absinthe drinker appears once again in this later painting, as one of a group of displaced characters: the Wandering Jew, the gypsy, and children from the slums – all inhabitants of the no man's land around Paris known as the "Zone." This painting corresponds to Baudelaire's concept of "the heroism of modern life" (p. 16), where there would always be victims of change.

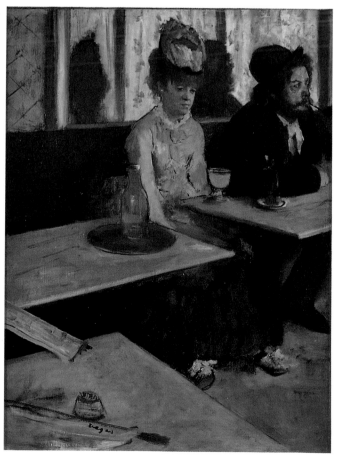

ABSINTHE
Edgar Degas; 1876; 36¼ x 26¾ in (92 x 68 cm)
Degas' *Absinthe* was painted 17 years after Manet's *The Absinthe Drinker*. In its oblique perspective and zigzag pattern of the tabletops, *Absinthe* reveals Degas' study of Japanese art, then popular in Paris (pp. 36–37). It coincided with the publication of Emile Zola's novel *L'Assommoir* ("The Club"), that traced a woman's downfall through alcoholism and poverty.

The Absinthe Drinker

1859-67; 71¼ x 41¾ in (181 x 106 cm)
The Absinthe Drinker was rejected from the Salon on several counts. The "Baudelairian" subject matter of a drunk down-and-out offended public morals, and the loose handling and lack of definition of the painting outraged the critics. Having left Couture's studio, Manet clearly still respected his former teacher, and invited him to his studio to view *The Absinthe Drinker*.

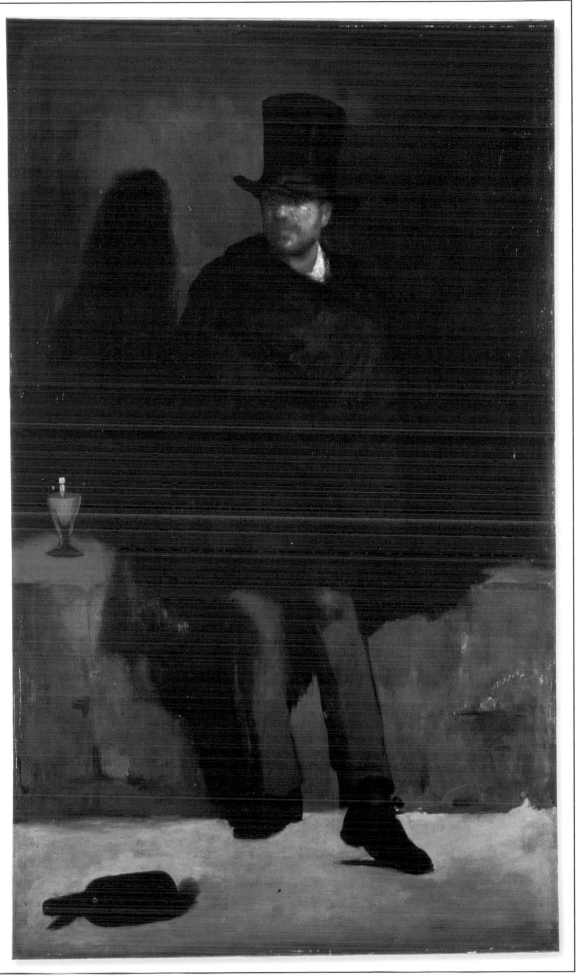

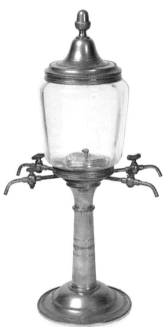

ABSINTHE FOUNTAIN
The absinthe was served from fountains that were placed behind the bar and was poured onto a spoonful of sugar into a glass. By 1874, two million gallons of absinthe a year were being consumed in France.

COUTURE'S LEGACY
The close-toned overall harmony of browns and ochres of Manet's *Absinthe Drinker* reveal Couture's remaining influence. Manet was not yet using the rich colors and strong contrasts that characterize his later paintings.

EXTENDED CANVAS
In 1859, the bottom part of this picture did not exist. Around 1867, Manet added a 16-inch strip of canvas, completing the figure and adding the glass of absinthe and the bottle. It then became part of his "beggar-philosopher" series (pp. 38–39).

Bohemian Paris

BOULEVARD MONTMARTRE
In this photograph of a bustling new Boulevard Montmartre, we can see the long, straight thoroughfares of Baron Haussmann's remodeled Paris (below).

B\ 1860 THE STREETS OF Paris were undergoing great transformation. Manet was very much the *flâneur* ("stroller" – p. 15, bottom left), and he daily frequented the most fashionable cafés to become a true connoisseur of life in the city. Paris and its inhabitants provided Manet with subjects for paintings throughout his career, and the complexities of modern urban life blended together to become Manet's "motif." He drew inspiration from all levels of society, lending as much significance to *The Absinthe Drinker* (pp. 12–13) as to the wealthy and fashionable figures depicted in his *Music in the Tuileries* (pp. 16–17). With his refined manners, elegant dress, and more importantly, his concern with modernity and the commonplace, Manet embodied all the traits of a *flâneur*.

PHOTOGRAPH OF MANET
"Fair-haired, twinkling, this Manet/From whom grace shone every way – /Bearded Apollonian,/Subtle, gay, and charming so,/Had an air from top to toe/Of the perfect gentleman."
– *Théodore de Banville*

Proposed boulevard, cutting through Parisian streets

HAUSSMANN PLAN
This street plan reveals the brutal means adopted by Baron Haussmann to create wide boulevards by demolishing existing streets and housing.

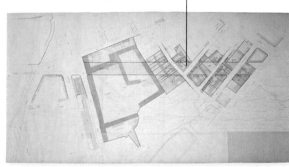

CAFÉ TORTINI
Cafés constantly attracted Manet, who, as Duret said, "was driven by the need to tread the select ground of the true Parisian."

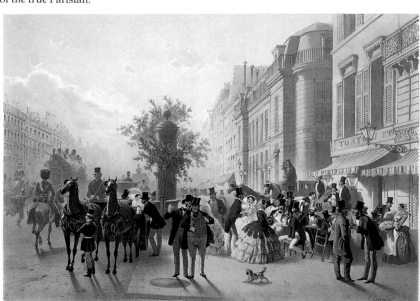

COUPES DE BARBES ET COUPES DE CHEVEUX
1ᵉ SÉRIE

ACADÉMIE DES COIFFEURS

THE FASHIONABLE BEARD
Manet was famous in his circle for his fashion-conscious appearance. Some critics took this, unfairly, to be a mark of his lack of "seriousness."

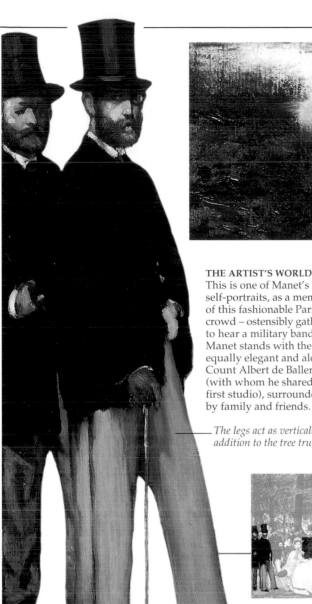

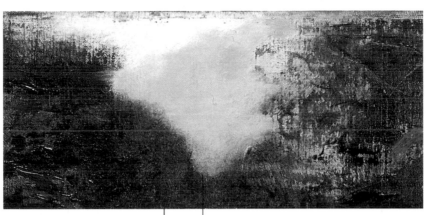

PATCH OF BLUE
The absence of any central focal point in *Music in the Tuileries* forces the viewer's attention out to the sides of the canvas. The prominent "arrow" of the blue sky, however, attracts the gaze and redirects it down to the center of the composition. Some areas of the foliage are painted thinly and scraped across the sky with a palette knife.

THE ARTIST'S WORLD
This is one of Manet's rare self-portraits, as a member of this fashionable Parisian crowd – ostensibly gathered to hear a military band. Manet stands with the equally elegant and aloof Count Albert de Balleroy (with whom he shared his first studio), surrounded by family and friends.

The legs act as verticals in addition to the tree trunks

Some areas of the foliage are applied in glazes over a warm earth base color

PLAYFUL SIGNATURE *below*
Despite Manet's complete rejection of the artistic "laws" of the day, he makes reference to traditional illusionism in this painting. He employs an old trick of the trade in his signature: a visual joke, painted trompe l'oeil (p. 63) behind the child's hoop.

The signature is painted as though it exists, physically, as part of the scene

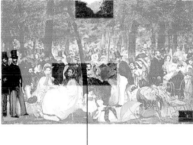

SYMMETRY AS A DEVICE *below*
The symmetrical "mirror image" of the two women helps prevent a central reading of the composition. Back to back, like duelists, they point with fan and umbrella to opposite sides of the painting. The figure of the woman with the umbrella, who occupies the central position, has almost no definition; we cannot "focus" on her, and so our attention is further diverted from the center out to the edges of the composition, where the action takes place.

The woman's profile under a veil is barely discernible

The man's face and beard are rendered in a few crude strokes

Spanish vogue

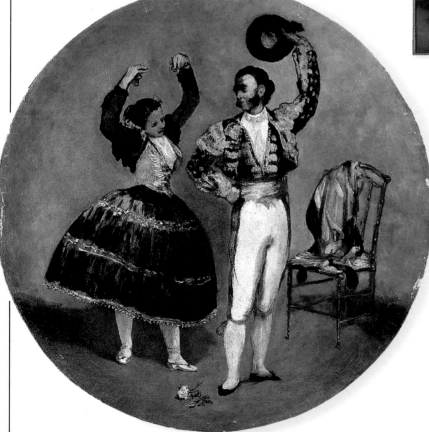

EUGENIE DE MONTIJO
The Spanish empress of France was a renowned beauty and influenced Paris fashions.

MANET'S PREOCCUPATION with Spanish themes during the 1860s was crucial to his development and brought him his first success at the Salon, where he received honorable mention for *The Spanish Singer*. His early "Spanish" paintings (he produced 15 in two years) were influenced largely by the Spanish vogue that had existed in Paris since the 1840s: the Louvre had already begun to acquire works by Spanish masters. But it wasn't until Manet actually visited Madrid in 1865 that the influence became profound, and he moved from the theatricality of the Spanish subject to an innovative use of paint and pictorial space, inspired mainly by Velázquez (p. 36).

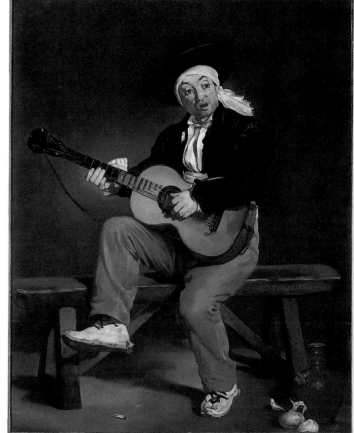

THE SPANISH SINGER
1860; 58 x 45 in (147 x 114 cm)
Following the failure of *The Absinthe Drinker* (pp. 12–13), Antonin Proust recalled Manet saying, "Perhaps they will understand better if I do a Spanish character." This was indeed more acceptable than the "real-life" Parisian drunkard, and in 1861 *The Spanish Singer* became Manet's first Salon success. Here is a Parisian who is clearly play-acting as a Spaniard. His clothes are from different regions of Spain, and his guitar, strung for a left-handed player, is held in the right-handed position, rendering it unplayable – a prop. This reminds us of the inherent deception in paintings – that this is, after all, only a flat surface with an arrangement of colored daubs of paint, which come together to represent a man playing a guitar.

TAMBOURINE DECORATED BY MANET
Manet always retained his admiration and enthusiasm for the color and drama of Spain. He produced a series of painted tambourines for a benefit sale at the Hippodrome in 1879, in aid of the victims of a flood in the Spanish city of Murcia.

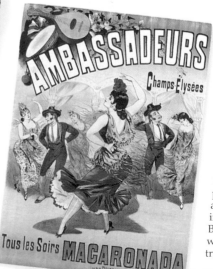

ARTISTS' HAUNT
Spanish dancers were a favorite subject in popular illustration, and there were many venues, such as the Ambassadeurs Theater, that advertised nightly entertainment. From 1862, the Mariano Camprubi dance troupe played two highly popular seasons at the Hippodrome. They played to an enthralled audience that regularly included Manet, Baudelaire, and Astruc, who planned Manet's trip to Spain in 1865.

LOLA DE VALENCE

1862; 48½ x 36¼ in (123 x 92 cm)
Lola Melea, known as Lola de Valence, was the star of the popular Mariano Camprubi dance troupe from Madrid. Drawn, as always, to things new and modern, Manet saw in Lola de Valence the opportunity to paint a contemporary Spanish type. He entered this painting in the 1862 Salon, probably in the hope that he would benefit once more from the continuing Spanish vogue, but it was rejected.

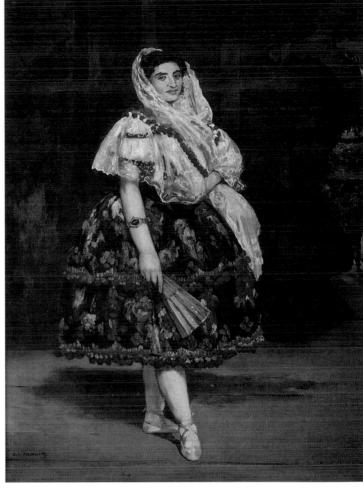

DANCERS' FEET

This work (done in oil on parchment in 1879) is identical to a detail in Manet's watercolor *The Spanish Ballet* (1862-63). He probably traced it, using this design as a basis for another in his series of painted tambourines (p. 18).

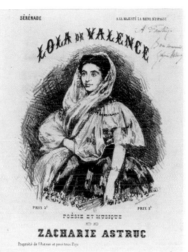

MUSIC SCORE

This score for a serenade composed by Zacharie Astruc is an indication of Lola de Valence's popularity in Paris at that time. On the cover is a lithograph designed by Manet. The serenade is dedicated "to Her Majesty, Queen of Spain," and it first went on sale in March 1863 at three francs a copy.

CRUEL RECORD

This spiteful caricature gives some idea of the original composition (see below). Manet must have been dissatisfied with the surrounding canvas, and it was not unusual for him to crop his paintings in this way (p. 26).

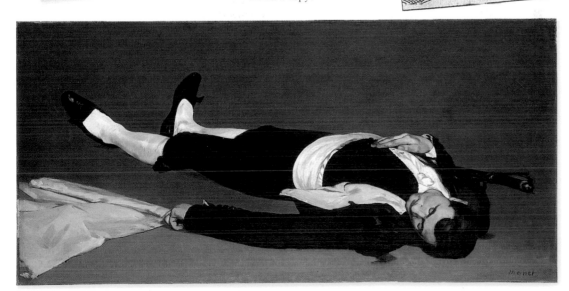

THE DEAD TOREADOR

1864; 30 x 60¼ in (76 x 153 cm)
At the Salon of 1864, Manet exhibited a multifigure composition called *Episode d'un Course de Taureaux* ("Incident in a Bullfight"). All that remains of the original composition are two fragments that Manet himself cut from the canvas. *The Dead Toreador* (left) is one of these fragments, and the other was reworked by the artist to become *The Bullfight* (p. 36). There is a marked similarity in Manet's *The Dead Toreador* to *The Dead Soldier*, a painting then attributed to Velázquez. Manet had probably seen this work in the Pourtalès (a private collection in Paris) before he made his trip to Spain in 1865 (p. 36). *The Dead Toreador* was exhibited at Martinet's gallery in 1865.

Victorine Meurent

VICTORINE MEURENT WAS Manet's favorite model. According to his friend Théodore Duret, Manet first met Victorine in 1862, "by chance in a crowd in a room in the Palais de Justice [and] had been struck by her original and distinctive appearance." She was then just 18 and had worked as a model in Thomas Couture's studio (pp. 10–11), although by that time Manet had already left. Meurent was known as a "fantastic character" who played the guitar and who could also paint (she later exhibited in the 1876 Salon when Manet's own works were rejected, and again in 1879). She was to enjoy a dubious kind of fame in her role as the naked courtesan Olympia (pp. 28–29), and her grace under the pressure of the attention she received from the press, as Manet's model, attests to her strength of character.

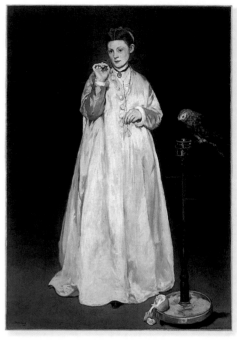

This is a powerful and uncompromising portrait, and Manet's unflinching gaze is returned with equal equanimity from his model.

WOMAN WITH A PARROT
1866; 72¾ x 50½ in (185 x 128 cm)
Manet's portrait of Meurent is a triumph of dignified feminine grace. It was probably painted in response to Courbet's (p. 29) overtly sexual, voyeuristic work on the same subject, which was exhibited at the 1866 Salon, and is executed with great subtlety and restraint.

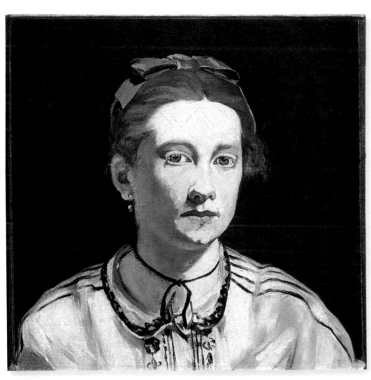

PORTRAIT OF VICTORINE MEURENT
1862; 17 x 17 in (43 x 43 cm)
Meurent's distinctive coloring was perfectly suited to Manet's "blond" palette. This portrait is quiet, essential Manet, and a good example of his habit of "floodlighting" his subject. As advice to a young painter, he said, "In a figure, look for the full light and the full shadow; the rest will come naturally." Manet's paintings were often labeled "flat," and his refusal to paint with half-tones handicapped his career. His love of contrast and the plastic qualities of paint distinguishes him from the Impressionists, who employed broken color and evenly distributed brushmarks.

A MODEL'S DECLINE
According to the writer, Tabarant, Meurent (left) posed for Manet "with long intervening lapses, for she had a will of her own." She went to America at the end of the 1860s, but returned to France in about 1872 and disappeared into oblivion. "That was the end. She soon took to drink."

PLEA FOR HELP
After Manet's death in 1883, Meurent wrote a moving letter to his widow, describing how, years before, when she was Manet's model, he had offered her several paintings. But now she had fallen on hard times. Unable to earn a living, she hoped Mme. Manet would honor Manet's earlier promise.

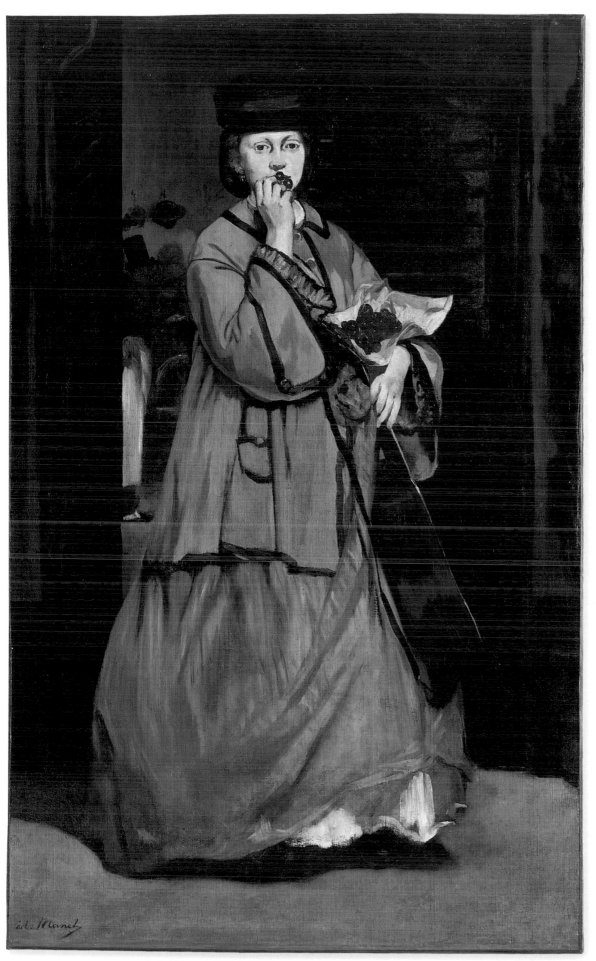

The Street Singer

*1862; 69 x 42¾ in
(175.2 x 108.5 cm)*

Antonin Proust recalled walking with Manet when a woman carrying a guitar stepped out from a café: "Manet went up to her and asked her to come and pose for him. She went off laughing. 'I'll catch up with her again,' cried Manet, 'and if she still won't pose, I've got Victorine.'" Manet's matter-of-fact treatment of this popular subject did not appeal to most critics, who preferred narrative and sentiment.

CRUDE APPEARANCE
To its critics *The Street Singer* appeared brash, its shapes oversimplified and its form lifeless.

PARIS CAFES
It was obvious to contemporary viewers that Manet's *The Street Singer* was posed by a model. She is too fashionably dressed to accurately represent one of the many street entertainers frequenting the cafés of Paris.

STUDIO PROP
The Street Singer's odd black hat was probably a studio prop of Manet's – it reappears in *Déjeuner sur l'Herbe*, this time on a man. This type of hat, the *faluche*, was traditionally worn by students.

KEY COLOR
Amid the criticism leveled at Manet's *The Street Singer*, most critics failed to notice its beautiful grays and greens, or how the wonderful still life of cherries sets the slightly acidic color key for the whole painting.

Salon of the rejected

JUDGING PROCEDURE
This cartoon is a parody of the system of rejection imposed by the panel of judges at the Salon each year.

WHEN THE JURY rejected over 4,000 paintings from the 1863 Salon, there was an outcry. The government was so inundated with complaints that the Emperor himself went along to the galleries to view the rejected works. According to legend, he was unable to distinguish between the accepted and the rejected in terms of merit, so took the unprecedented step of ordering a separate exhibition for the rejected paintings, to run concurrently with the official Salon. Many withdrew, but Manet was one of the artists who took up the challenge, showing three paintings, including his scandalous *Déjeuner sur l'Herbe*.

DANGEROUS ART
This caricature was a warning to unsuspecting art lovers – to keep their distance from such volatile work.

THE VOTING JURY
The jury consisted of 24 men, successful academic painters – and all very conservative. They voted en masse (below), raising a staff or cane if they felt a painting worthy of acceptance. In 1863 Gustave Courbet (p. 25), who expected automatic entry to the Salon as a previous prize winner, had a painting barred by the Salon and the Salon des Refusés on grounds of immorality.

LA FIN DU SALON.
Le commissionnaire qui emporte les tableaux de M. Manet ayant commis l'imprudence d'oublier de les couvrir d'un voile.

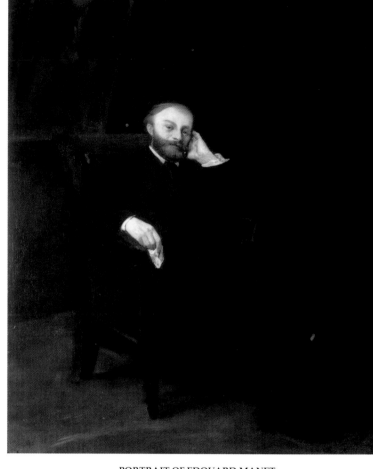

PORTRAIT OF EDOUARD MANET
Alphonse Legros; 1863; 24¼ x 19¾ in (61.5 x 50 cm)
Alphonse Legross's small portrait of Manet also hung in the first Salon des Refusés, presumably near Manet's own works, as the paintings were arranged in alphabetical order by artist. Here we can see a philosophical and quietly defiant Manet. One can only imagine how the proximity of this self-assured presence would have further exasperated an outraged public.

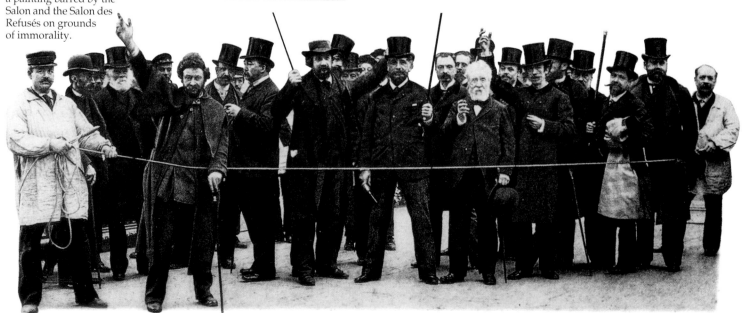

HANGING PROCESS

Inside the *Palais de l'Industrie*, where the Salon was held, pictures were hung in tight rows from floor to ceiling, and the order of hanging decided at floor level in advance (right). There was a distinct hierarchy in positioning, which the public understood. If a painting (particularly a small work) was "skied" – hung near the ceiling – there was little or no chance of it receiving any attention at all. This led artists to produce canvases of enormous scale that at the very least would automatically attract attention.

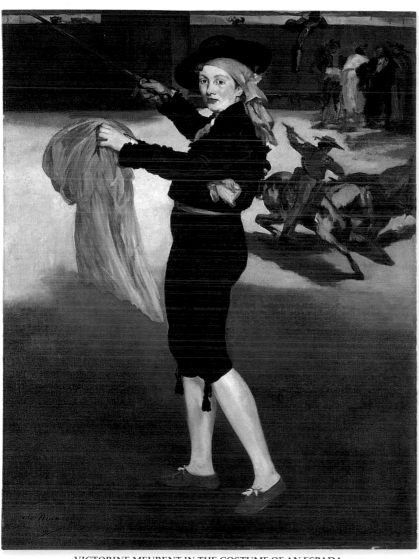

VICTORINE MEURENT IN THE COSTUME OF AN ESPADA

1862; 65 x 50¼ in (165.1 x 127.6 cm)

This truly strange painting of Victorine Meurent dressed as a matador was one of three works Manet exhibited at the Salon des Refusés. It was hung alongside *Déjeuner sur l'Herbe* (pp. 24–25) and went largely unnoticed in the controversy surrounding the painting. Even so, this painting is a bold work – in placing Victorine in male clothing, within a bullfight setting, and in a decidedly unusual composition that bears little relation to the main figure, Manet was taking risks. Indeed, the painting was seen as provocative by some critics. Manet owned a collection of Spanish costumes that were used in a number of paintings, including this one and *Young Man in Majo Costume* (which hung on the other side of *Déjeuner sur l'Herbe* at the Salon des Refusés).

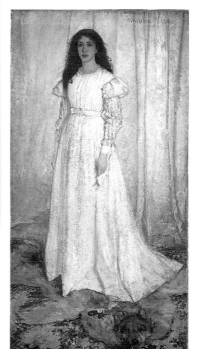

ORIGINAL CATALOG

When the Salon des Refusés opened to the public on May 11, 1863, 7,000 visitors attended on the first day. This public interest contrasted sharply with the almost total absence of serious critical attention the exhibition received.

THE WHITE GIRL

James McNeill Whistler; 1863; 30 x 20 in (76.5 x 51 cm)

This painting, by the American artist J.M. Whistler, caused almost as much of a sensation at the Salon des Refusés as Manet's *Déjeuner sur l'Herbe*, and was probably influential in Manet's own attempt at a "white" painting two years later (p. 27).

A bourgeois scandal

Wʜᴇɴ *Déjeuner sur l'Herbe* ("Luncheon on the Grass") was first shown to the public at the celebrated Salon des Refusés in 1863 (pp. 22–23), it caused an outcry. What upset the critics most was Manet's audacity in "quoting" the old masters, tarnishing time-honored themes by parading vulgar modern counterparts in their place. These were not nymphs and shepherds of myth and legend, but modern Parisian city dwellers indulging their petit-bourgeois passion for picnicking in the country. Manet further exasperated the critics by the ambiguity of the painting's title, which gave no explanation as to why the woman was naked and the two men fully clothed. This reflects Manet's concern with the painted surface, so anticipating the "art for art's sake" stance typical of 20th-century modern art. On seeing the painting, Emperor Napoleon reputedly dismissed it as obscene, and the cartoonists and writers for the popular press had a field day. Few serious critics came to Manet's defense, and *Déjeuner sur l'Herbe* became the *succès de scandale* of the exhibition.

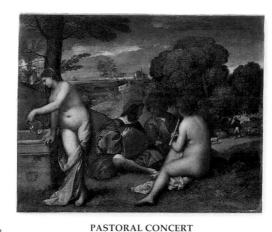

PASTORAL CONCERT
Titian; 1576; 43¼ x 54¼ in (110 x 138 cm)
According to Antonin Proust, it was Manet's intention to "redo" Titian's *Pastoral Concert* (then attributed to Giorgione). Manet has translated this classical scene into a contemporary setting, uniting the ancient and modern worlds to reveal a modern tradition.

JUDGMENT OF PARIS (AFTER RAPHAEL)
Manet directly copied the three figures on the right of this engraving by Marcantonio Raimondi for the figures in *Déjeuner sur l'Herbe*. This partly explains the puzzling gesture of the reclining man in Manet's painting.

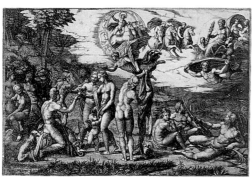

PREPARATORY STUDY
Victorine Meurent (pp. 20–21) was the model for the seated nude in this study for *Déjeuner sur l'Herbe*. She is recognizable by her red hair – subdued to brown in the final work. Both Manet's brothers, Eugène and Gustave, posed for the seated man to the right of the canvas, and Ferdinand Leenhoff (Suzanne Leenhoff's brother) was the model for the remaining figure.

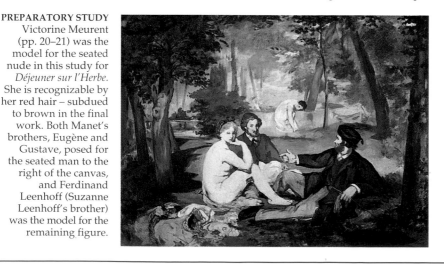

Déjeuner sur l'Herbe

1863; 82 x 104 in (208 x 264 cm)
The lack of explanation of this strange scene made it totally incomprehensible to most contemporary viewers. Manet may have wished to outdo his older rival, Gustave Courbet (right), who had already scandalized the public with his realism, and was seen to exceed the bounds of decency (and undermine social values). Courbet, however, in depicting a naked woman at ease in the company of clothed men (p. 25), had painted a "legitimate" contemporary nude – the professional life model. In this self-consciously modern painting the woman's nudity is an enigma.

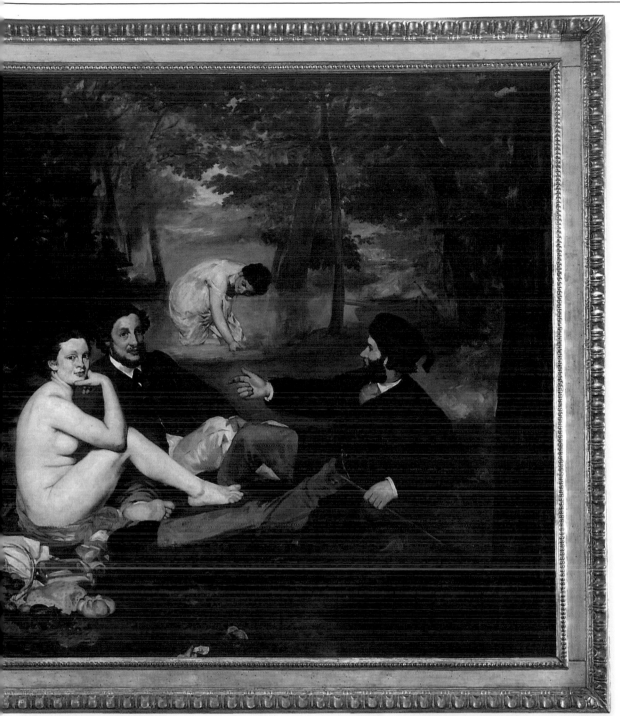

A STUDIO PAINTING

Déjeuner sur l'Herbe was painted entirely in Manet's studio, and he makes no pretense otherwise. The landscape, however beautiful, is artificial and painted as a backdrop, a stage set for the figures. The space is very shallow and enclosed, with only a tiny patch of sky to suggest a horizon.

SPATIAL GAMES

There is an odd distortion of space in the relation between the bathing woman and the main group. Considering the distance implied by the receding trees and perspective of the river, she appears gigantic, particularly in proportion to the small boat moored just a few feet away.

CONTEMPORARY STILL LIFE

The clothes and fruit "negligently" scattered on the ground not only add colorful accents to the overall green-brown of the painting, but set the scene firmly in the modern world. The elegance of the clothes suggests worldly sophistication and self-conscious style.

HUMOROUS TOUCH

Hidden in the grass, in the bottom left-hand corner of the painting, is a well-camouflaged frog. It has a less earthbound companion in the finch, flying over the group, almost central to the composition.

GUSTAVE COURBET
Proud of his peasant stock and largely self-taught, Courbet was anti-intellectual, passionate, and brash, and believed in painting only "real and existing things."

THE ARTIST'S STUDIO
Gustave Courbet; 1854-55;
142¼ x 235½ in (361 x 598 cm)
Courbet's huge canvas – 12 feet (3.6 meters) high by 20 feet (6 meters) long – was an immensely ambitious work, containing 28 figures. When this painting, together with *A Burial at Ornans*, was rejected from the Exposition Universelle of 1855, Courbet exhibited it in his own pavilion, an unorthodox move that Manet imitated in 1867.

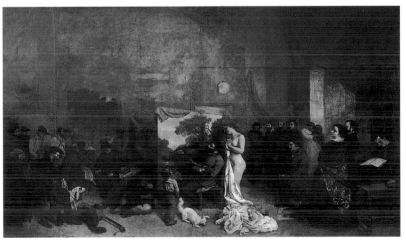

A new controversy

AFTER THE PUBLICITY GENERATED by the Salon des Refusés the previous year (pp. 22–23), the judges for the official 1865 Salon were cautious about rejecting too many works, and *Olympia* was accepted. Again, Manet was to outrage the public and critics. It is difficult to see just why *Olympia* was so shocking when, on the surface, it appears to be a formal nude within the long tradition of the nude in Western art. Olympia's power lay in her gaze: while most contemporary nudes were portrayed as either anonymous nymphs or mythological figures – tacitly understood to be courtesans – Manet painted a courtesan as a courtesan, and her resolute gaze defies question of that role.

RECLINING NUDE
In the more modest pose of this chalk drawing, we can see an earlier idea for the as-yet unrealized figure of Olympia. In this version, drawn three years before Manet painted *Olympia*, she toys with the end of a plait of hair, and her attitude is altogether more playful. In concentrating solely on resolving the figure, Manet has left the face totally blank; nevertheless, Victorine Meurent's compact proportions are clearly recognizable in these bold single lines.

Olympia

1863; 51 x 74¾ in (130 x 190 cm)
What made *Olympia* doubly disturbing was her very real identity – that of Victorine Meurent. She was well known for her strong character and Manet, who said of the painting, "I painted what I saw," has inarguably captured her spirit. Olympia's hand presses down on her thigh, thereby hinting at Meurent's awareness of her own nakedness, and simultaneously at the courtesan's knowledge of the power of her sex.

OLYMPIA'S "CLIENT"
Olympia's gaze further unsettles as she confronts us – who, as spectators, must assume the role of potential client.

THE BLACK CAT
Manet has replaced the peacefully sleeping dog in Titian's *Venus of Urbino* (p. 29) with a bristling and vaguely sinister black cat.

SEXUAL DRESSING
Victorine's characteristic neck ribbon is her only clothing, and hints at a wrapped luxury awaiting purchase.

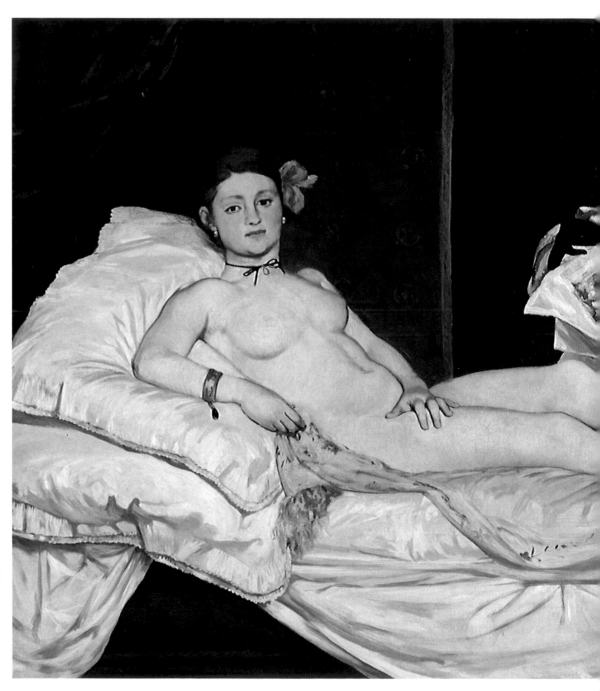

VENUS OF URBINO

Titian; 1538; 46¾ x 65 in (119 x 165 cm)
Manet took the basic composition of *Olympia* directly from Titian's *Venus of Urbino*, and Victorine Meurent (pp. 20–21) adopted the classical pose of a reclining Venus. The similarities with Titian's Venus end there, however, and in place of his rather coy, passive goddess is a coolly self-assured Olympia. No longer Venus in the guise of the courtesan, this is the courtesan triumphing as a modern Venus.

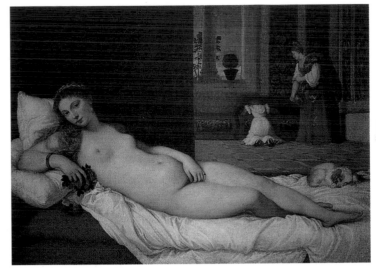

RIDICULED PAINTING

In addition to the hostile reaction of critics (so strong that the painting was moved to the far end of the exhibition), *Olympia* provoked shocked, embarrassed laughter from the public. Bertall's caricature, depicting a grubby-looking Olympia with steaming feet, is representative of the ridicule the painting received from the press.

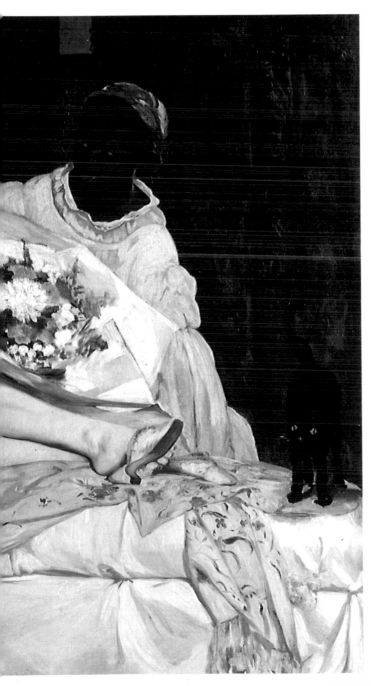

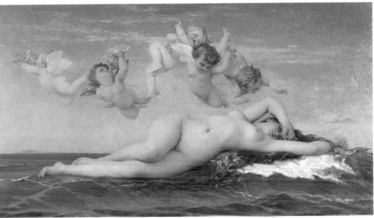

BIRTH OF VENUS

Alexandre Cabanel; 1862; 51¼ x 88½ in (130 x 225 cm)
In contrast to the provocative realism of Manet's *Olympia*, Cabanel's *Birth of Venus* (purchased by Napoleon III at the official 1863 Salon) is a voyeuristic fantasy. Her unnaturally white, hairless body is as vulnerable and unthreatening as a baby's. With her arms partially obscuring her face, she is safely anonymous.

NEW SUPPORT

Emile Zola's booklet (above) publicly defended Manet and his art. In thanks, he later painted the writer's portrait (p. 37).

ACCOMPANYING POEM

"When, tired of dreaming, Olympia awakens/Spring enters on the arm of the mild black messenger/She is the slave who, like the amorous night/Comes to adorn with flowers the day beautiful to behold/The august young woman in whom ardor is ever wakeful."
Zacharie Astruc

An elegant realism

MANY OF MANET'S still lifes were painted as gifts for his friends and supporters. He gave *White Peonies and Secateurs* to his friend, the realist writer and critic Champfleury; and the "careless" arrangement of this realist still life, with its addition of a pair of secateurs, would have been appreciated by the critic. The work reveals Manet's pure, unadulterated mastery of paint. The modest scale, composition, and subject matter allow us to see Manet as a painter, first and foremost – unencumbered by more complex pictorial issues. With generous, fluid brushstrokes, he has captured the intrinsic qualities of leaf and petal, while simultaneously drawing the viewer's attention to the physicality of the paint.

Crimson lake

Raw umber

Viridian

Lead white

Ivory black

Naples yellow

Chrome yellow

MATERIALS
The secret of this small painting's power lies in part in Manet's greatly restricted palette. In effect, the composition consists of three colors: the warm brown ochre of the empty background; the deep green of the partially obscured foliage; and the warm whites of the flowers, painted in high relief and in sharp contrast to the rest of the canvas.

White Peonies and Secateurs

1864; 12¼ x 18½ in (31 x 47 cm)

The virtuoso brushwork of this painting reveals Manet's affinity with the grand master of still life, Jean-Baptiste Chardin (p. 32). In 1763, Diderot wrote this appreciation of Chardin's (only surviving) flower painting, which could also apply to Manet: "This is unfathomable wizardry. Thick layers of color are applied one upon the other and seem to melt together. Draw near and everything flattens out and disappears; step back and all the forms are re-created."

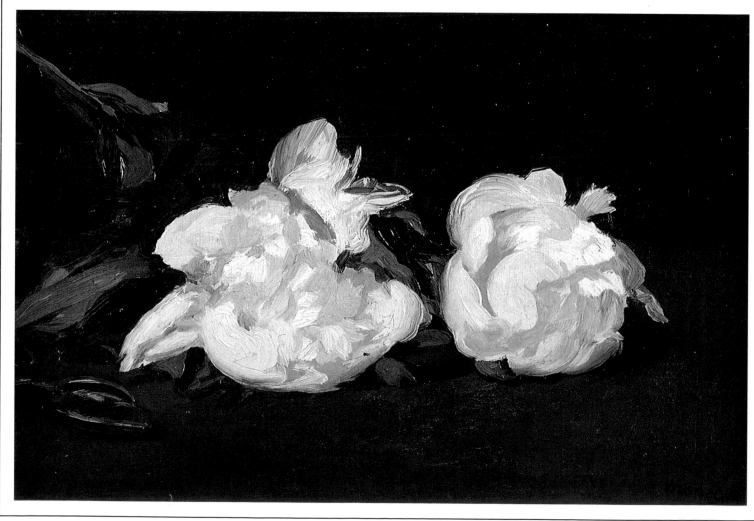

Canvas left bare

Layered impasto

Rapid strokes

Dragged paint

Paint mixed on the surface of the painting

Traces of viridian green

Streak of unmixed chrome yellow

HEART OF THE FLOWER

Manet simulates the intrinsic quality of the tightly clustered inner petals with an inspired play of impasto and color over the flatness of the canvas – still visible in bare patches. He has created a physical, three-dimensional paint structure, made up of layers of short, spiky brushstrokes. These catch the natural light falling on the canvas, and by projecting physically from the smooth, empty background, they serve to make the flower head all the more "real."

ENERGETIC BRUSHWORK

In this animated detail we can see Manet's instinctive manipulation of the paint's surface. He has mixed the colors on the actual canvas, dragging the dark brown-black of the background into the white of the petal to create shadow and give solid definition to the bloom. His brushwork is applied rapidly, with great energy and spirit, and his experience and understanding of the medium are obvious. The viewer can sense his excitement and enjoyment of the paint.

Fluid brushwork

Dense opaque paint

Thin layer of transparent paint

Thick-over-thin buildup of paint surface

CAPTURING FORM

This detail can be seen as representative of Manet's direct, intuitive response to form. He was able to create form with the bare minimum of strokes, striving always to preserve the freshness of the first marks in his finished paintings. This apparent spontaneity, however, is the result of constant scraping off and reworking of the surface.

Sharp-edged definition

SPEAR OF GREEN

The foliage plays a secondary role to the brilliance of the flower heads. The dark, somber greens dissolve completely into the background at times, allowing the cool whiteness of the blooms to dominate the canvas completely. Where the foliage has more definition, it serves to support the structure of the composition, so that the flower heads do not "float" in the empty space of the background. The leaf in this detail is painted in one or two bold, thick strokes.

The still life

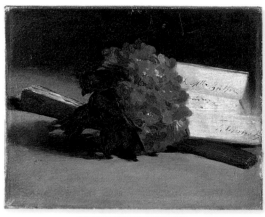

MANET WAS A MASTER of the still life, from tiny works of great dignity, to large, complex arrangements in the 18th-century Dutch and French tradition. The still-life elements of his larger compositions also play a crucial role, functioning as separate, sometimes dislocated, "messages." Manet often used the still life as a prop – such as the oyster shells artfully scattered at the feet of *A Philosopher* (pp. 38–39) or the unplayable guitar in the hands of his Parisian *Spanish Singer* (pp. 18–19) – to remind us that painting is, after all, a deception. These still lifes also function as affirmations of contemporary reality: for instance, the beautiful still life of clothes of contemporary Paris fashion in *Déjeuner sur l'Herbe* (pp. 24–25) insists on a non-historical, non-mythological interpretation of the scene.

Violets

BOUQUET OF VIOLETS
1872; 8¾ x 10¾ in (22 x 27 cm)
Manet painted this small, delicate still life in thanks to Berthe Morisot for posing for her portrait (p. 49), in which she wears a bunch of violets at her throat. Manet has used the device of a little note to sign and dedicate the painting to her.

THE RAY FISH
Jean-Baptiste Chardin; 1726; 45 x 57½ in (114.5 x 146 cm)
Chardin was born in Paris in 1699. The son of a carpenter, he became an academician in 1728 after he had attracted attention with *The Ray Fish*. He spent his career, spanning 40 years, in the production of still lifes and domestic interiors, which expressed a world of simplicity, dignity, and order. The cat, bristling and arching at some unseen presence in *The Ray Fish*, reappears in Manet's painting *Olympia* (p. 29 and detail, bottom left).

Still Life with Carp

1864; 29 x 36¼ in (73.4 x 92.1 cm)
The year 1864 saw the advent for Manet of a phase of still-life painting that was largely influenced by one of the great French painters: Chardin. Due in part to a major exhibition of his work at the dealer Martinet's gallery in 1860, Chardin was enjoying something of a revival. Manet was able to see over 40 works by Chardin and would have recognized, in their rich, brilliantly textured brushwork, a spirit close to his own. With his *Still Life with Carp*, Manet emulates and borrows certain stylistic devices from Chardin, such as the knife protruding from the picture plane and the diagonal composition. Like Chardin's magnificent *The Ray Fish*, Manet has captured the glistening, muscular body of the fish that, although dead, exudes life.

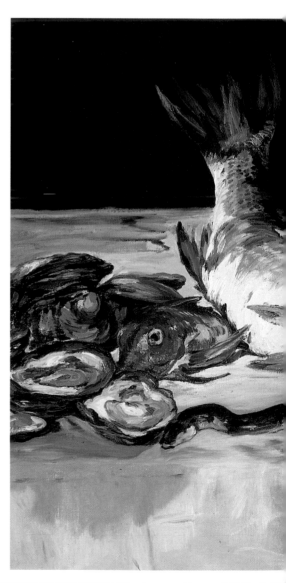

STARTLED CAT
Olympia's cat (p. 29) bears a marked resemblance to the startled cat in Chardin's *Ray Fish*.

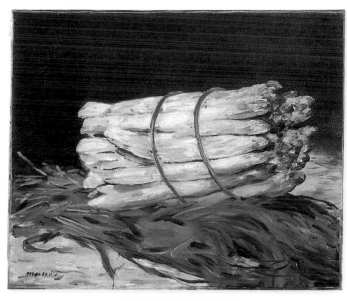

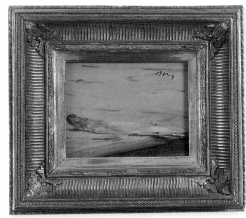

THE ASPARAGUS
1880; 6¼ x 8¼ in (16 x 21 cm)
The story behind this work does much to endear Manet to us. He had sold the *Bunch of Asparagus* (left) to Charles Ephrussi, editor of the *Gazette des Beaux-Arts*, for 800 francs. Ephrussi sent 1,000 francs instead, so Manet painted this tiny canvas and sent it to him with a note: "There was one missing from your bunch."

BUNCH OF ASPARAGUS
1880; 17¼ x 21½ in (46 x 55 cm)
Considering its modest subject, this is a large canvas. The outsize bundle of asparagus is painted with such vitality and sheer love of paint that it could stand for Manet's entire oeuvre. It exhibits his enduring love of strong contrasts and how he used black as a foil for color, and achieved the strange pale luminosity peculiar to white asparagus.

THE HAM
1875–78; 13 x 16½ in (33 x 42 cm)
Manet said, "The still life is the touchstone of painting." For two centuries still lifes such as *The Ham* had been regarded by French academics as the poor relative of all the other genres. The increased output of still lifes during the 19th century was felt as a threat by the academics – who had awarded history painting the highest position within their hierarchy, and still life the lowest. The photo (left) shows Degas with *The Ham* hanging on his wall.

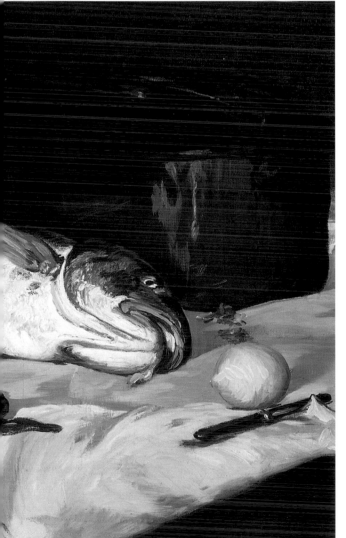

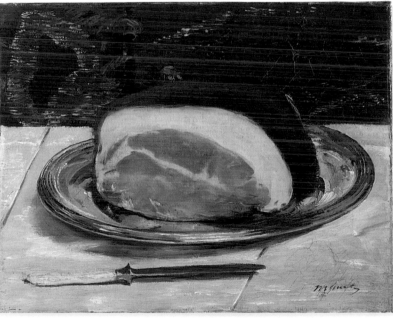

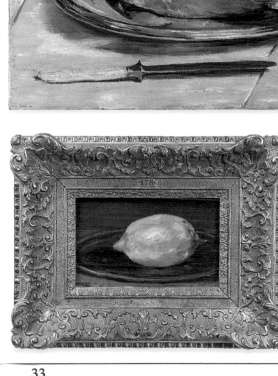
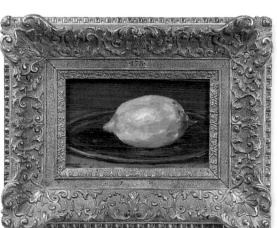

THE LEMON
1881; 5½ x 8¼ in (14 x 21 cm)
Manet told the painter Georges Jeanniot, "Concision in art is a necessity." It would be difficult to find a more concise painting than this. Manet understood well the power of economy of line and produced masterpieces of understatement, such as his portraits of Berthe Morisot (p. 46), Victorine Meurent (p. 20), and the truly magnificent *Fifer* (p. 41).

The cycle of life

ONE OF MANET'S FAVORITE flowers was the peony, which had entered Europe from China early in the 19th century. Manet grew peonies in his garden and in 1864 he painted them at least seven times – their large blooms and loose structure were well suited to his generous brushwork. *Peonies in a Vase* is the definitive work from the series he produced that year. There is very little symbolism or narrative in Manet's work, a factor that contributed to his continued rejection by traditional critics and Salon juries (p. 21). Where he chose to paint a subject that was traditionally loaded with symbolic interpretations, he either allowed the naturally inherent "meanings" – found, for instance, in dying flowers (right) – to speak for themselves, or, he stripped the subject of its symbolic meaning, reducing it to its everyday role, as in *Soap Bubbles* (below, left). *Peonies in a Vase* is a subtle re-working of the 17th-century Dutch tradition of "Vanitas" paintings – allegories on the themes of death and the brevity of life.

"WHO CAN EVADE IT?"
The verse accompanying Hendrick Goltzius's engraving (1594) on the "Vanitas" theme reads: "The fresh, silvery flower, fragrant with the breath of Spring, withers instantly as its beauty wanes. Likewise, the life of man, already ebbing in the newborn babe, disappears like a bubble or like fleeting smoke."

SOAP BUBBLES
Jean-Baptiste Chardin; 1733;
36½ x 29¼ in (93 x 74.5 cm)
Chardin (p. 32) took this theme of a boy blowing bubbles from Dutch 19th-century "Vanitas" paintings, in which the bubble was a common symbol for the brevity of life. Chardin's *Soap Bubbles* is a dignified, almost solemn work that was a departure from the generally lighthearted depictions of the subject, and it inspired Manet's painting on the same theme. Chardin worked slowly and painstakingly, and would often duplicate successful images. He made several close copies of this painting.

SOAP BUBBLES
1867; 39½ x 32 in (100.5 x 81.4 cm)
Manet was inspired as much by Chardin's naturalistic treatment of this theme as by the subject. Manet's painting is devoid of moral sentiment. It is, rather, a portrait of a 15-year-old boy, Léon Leenhoff (pp. 26–27), caught in the complete absorption of his task. Like Chardin's, Manet's strength was in stillness rather than action, and he has chosen to portray the same still moment of precariousness. Manet had recently seen Chardin's *Soap Bubbles*, and this, together with the memory of Couture's own sentimental version of 1859, probably induced Manet to honor the old master and challenge his old teacher (pp. 10–11) with his new version.

PORTRAIT OF EVA GONZALES
1870; 75¼ x 52¼ in (191 x 133 cm)
In 1869, Eva Gonzalès became Manet's first and only pupil. She is portrayed here according to the custom for depicting women artists – in her Sunday best, "posing" as a painter. Manet later painted her really at work, swathed in an apron.

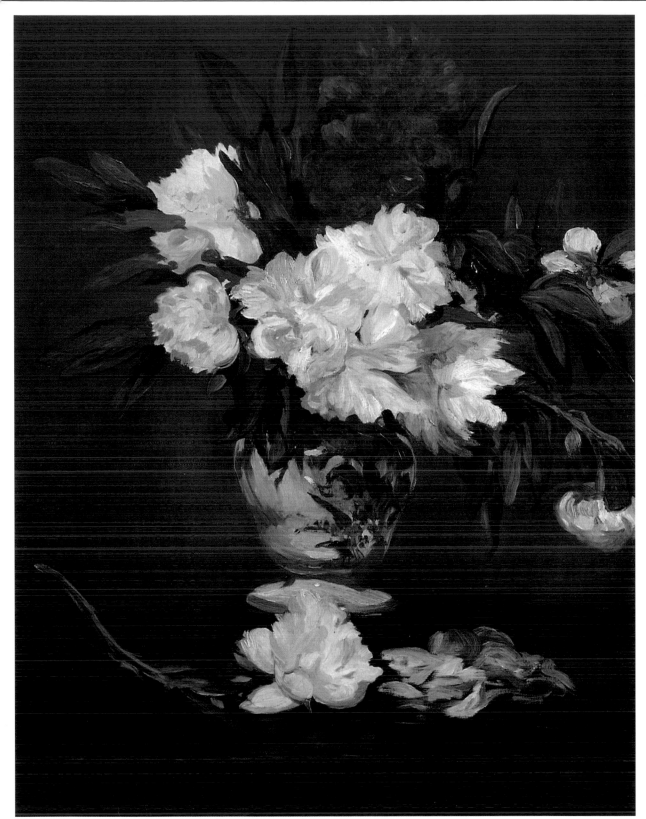

STAGES OF GROWTH

Peonies in a Vase can be interpreted in a cyclical fashion, starting with the fresh, buoyant leaves and immature blossoms on the left, moving across to the full-blown pale pink blooms, which are surmounted by two climactic blood-red peonies.

DYING FOLIAGE

From the highest point of dark red, the direction shifts around farther, with a sweeping movement, to the heavy stems on the right, which are collapsing under their own weight. The leaves droop, and the flower heads hang upside down.

FALLEN PETALS

The sequence ends with the pile of petals, which have dropped onto the tabletop beneath the pale vase. Their beauty is gone and they are already beginning to discolor: a reminder of the physical reality of death.

LIFE RENEWED

Life and death appear together at the foot of the vase: the dropped petals represent death, but the freshly cut blossom's arching stem takes our gaze back to the beginning of the cycle, on the side of life.

Peony from *Portrait of Eva Gonzalès* (left).

A COPY
Manet appears to have made a direct copy of the peony from his earlier painting (above).

Peonies in a Vase

1864; 36¾ x 27¾ in (93.2 x 70.2 cm)

"What a painter! He has everything, an intelligent mind, an impeccable eye, and what a hand!" said Paul Signac. Even Manet's harshest critics couldn't deny his technical dexterity and the sensual, painterly qualities of his flower paintings. Manet was well aware of his technical skills and his talent, and contrary to the often radical appearance of his work, he was constantly surprised by its rejection.

Spain and Japan

At the end of Autumn 1865, Manet set off for Spain. He traveled alone, with an itinerary planned for him by his friend Zacharie Astruc (p. 19). The reason for his trip was to see the works of the great Spanish masters that Manet had for so long admired at second hand: Goya, El Greco, and above all, Diego Velázquez. Manet returned to Paris with a more significant understanding of Velázquez's genius, which he translated into his own works, initially in a series of full-length portraits (pp. 38–39). In his *Portrait of Emile Zola*, Manet acknowledges his debt to Velázquez, as well as his enthusiasm for contemporary Japanese art, at that time still relatively new to France.

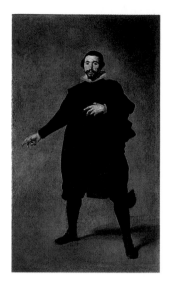

PABLILLOS DE VALLADOLID
Diego Velázquez; 1632–34; 82¼ x 48½ in (209 x 123 cm)
Manet wrote of Velázquez's portrait of the actor Pablillos in the Prado, Madrid: "It is perhaps the most astonishing piece of painting ever done."

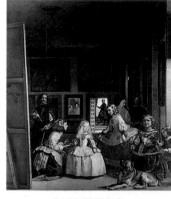

LAS MENINAS
Velázquez; 1656; 125¼ x 108¼ in (318 x 276 cm)
Manet's admiration for Velázquez led him to award the master the ultimate accolade of "painter of painters."

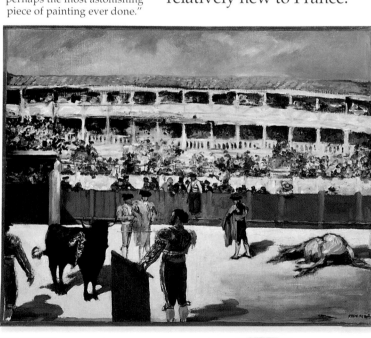

BULLFIGHT
1865–66; 19 x 23¾ in (48 x 60.4 cm)
To Astruc's astonishment, Manet returned from Spain after only ten days, hating the food and climate. Manet had attended several bullfights and made sketches that he later developed into paintings, such as this festive work, oddly lighthearted despite its bloody subject.

WITNESS TO A SPECTACLE
Manet described the bullfight as "one of the finest, most curious, and most terrifying sights to be seen."

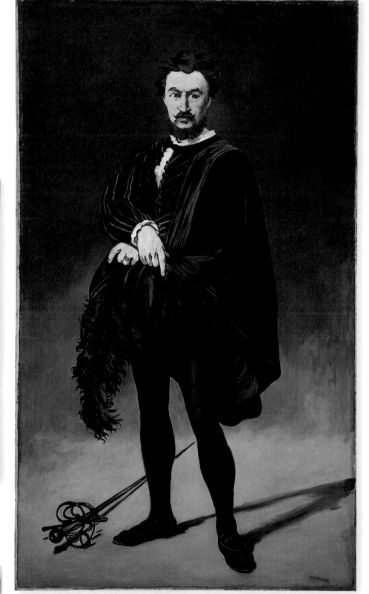

THE TRAGIC ACTOR
1865–66; 73¾ x 42½ in (187.2 x 108.1 cm)
Manet painted this portrait of the brilliant tragedian Philibert Rouvière, in the role of Hamlet, soon after his return from Spain. It is the first of Manet's paintings in which his newly made discoveries were put into action, and we can see the direct references he made to Velázquez's *Pablillos de Valladolid* (above).

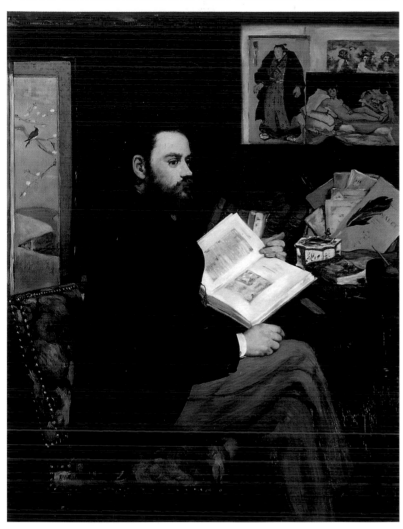

THE WRESTLER ONARUTO NADAEMON OF AWA PROVINCE

Japanese prints, such as this one by Kuniaki II, had entered Europe in the middle of the century, but Japanese art made its first real impact in France at the Exposition Universelle in 1867. Manet was an early collector, attracted by the bold simplicity of the drawing and the flat areas of bright color that were especially characteristic of *nishiki-e* prints.

EMILE ZOLA AND JAPAN

Zola was an avid collector of *ukiyo-e* prints – the Japanese equivalent of realistic art. His home was filled with Far Eastern objets d'art, and the Irish writer George Moore recalled seeing prints "of furious fornications ... a rather blatant announcement of naturalism."

JAPANESE ILLUSTRATIONS

This is a page from *The Manga*, a book of illustrations that ran to 15 volumes, containing thousands of studies of animals, plants, fish, insects, and people going about their everyday life. It was the work of the great 19th-century Japanese artist Katsushika Hokusai, and his brilliant woodcuts drawn directly from nature are executed with humor, modesty, and incredible clarity of observation.

PORTRAIT OF EMILE ZOLA

1867–68; 57½ x 45 in (146 x 114 cm)

Manet's portrait of Zola is an essentially "Japanese" work, achieved with the aid of exotic props and, more significantly, by its pictorial organization: the shallow space, silhouetted figure, and strong decorative elements of repeated flat shapes and rectangles parallel to the picture's edge. It is also a statement of Manet's eclecticism: Japan and Spain appear together (represented by Kuniaki's *Wrestler*, above, and Velázquez's *Little Cavaliers*), framed above the desk, and joined by Manet's *Olympia*, itself a hybrid of old and new. The open book is Manet's copy of Charles Blanc's *Histoire des Peintures* – a valuable source of older art for Manet.

JAPANESE WOODCUT

Manet has lifted a detail straight from the page of plants and flowers from Hokusai's *Manga* (above, right) and has only altered it slightly for the ex libris page of Mallarmé's poem (right).

"AFTERNOON OF A FAUN"

Manet worked on several collaborations with his friend, the symbolist poet Stéphane Mallarmé. In addition to illustrating Mallarmé's own work (right), Manet produced a series of lithographs for Mallarmé's translation of Edgar Allan Poe's "The Raven" and *The Poems of Poe*, sharing Mallarmé's enthusiasm for the American writer.

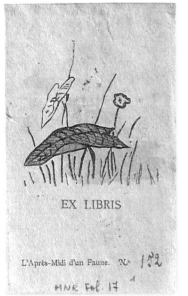

Beggar-philosopher

A NEW CITY
Baron Haussmann's
(p. 14) reordering of
Paris included the
extension of its 12
arrondissements to
the 20 in existence
today. The rapidly
expanding city burst
its boundaries and
forced those living on
the outskirts into a zone
that was neither city nor
suburb: the *banlieue*.

MANET HAD GREATLY admired Velázquez's imaginative portraits of the philosophers Aesop and Menippus in the Prado, Madrid, in 1865. He wrote to Astruc: "I have found in this work a realization of my ideal in painting; the view of these masterpieces has given me great hope and full confidence." On Manet's return to Paris, this new rush of confidence resulted in a series of "beggar-philosopher" paintings based on Velázquez's philosophers; indeed, the strong similarity between *Menippus* and *A Philosopher* suggests a homage to the Spanish master. In transporting Velázquez's philosophers into the 19th century in the guise of beggars, Manet, in his position as artist and social commentator, identifies with the outsider – perhaps a legacy of Couture's romantic concept of the artist as isolated genius.

NAPOLEON III
Manet's "beggar-philosopher" series represents some of the victims of the rapidly changing Parisian society under Emperor Napoleon III. Conditions for urban "gleaners," such as rag pickers and beggars, had steadily worsened.

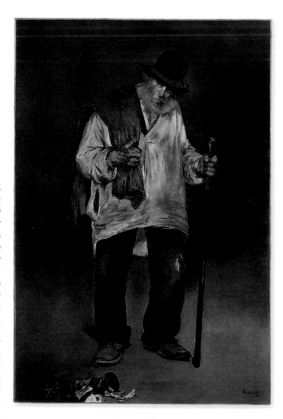

LE CHIFFONNIER
1865; 76¼ x 51¼ in (195 x 130 cm)
The chiffonnier ("rag picker") was an outsider whose livelihood was under threat in a "new" Paris that had no place for him. He came to represent pre-Haussmann Paris, and his image appeared in many popular publications. Manet's *Absinthe Drinker* (right and pp. 12–13) was based on a real-life chiffonnier, Collardet.

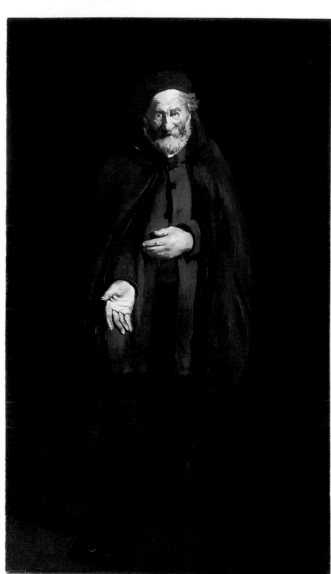

The Beggar (The Philosopher)
1865; 946¼ x 43 in (118.5 x 109 cm)
In this painting, Manet's philosopher actively plies his trade as a beggar. His outstretched hand, however, suggests an offering as much as a supplication, as though bestowing wisdom on the viewer, the impoverished. His mock-humorous expression is also world-weary and thoughtful. There is a strong color affinity between this painting and Delacroix's *Barque of Dante* (pp. 8–9), and it is tempting to interpret Manet's beggar-philosopher as a distant relative of the great poet-philosopher, Virgil.

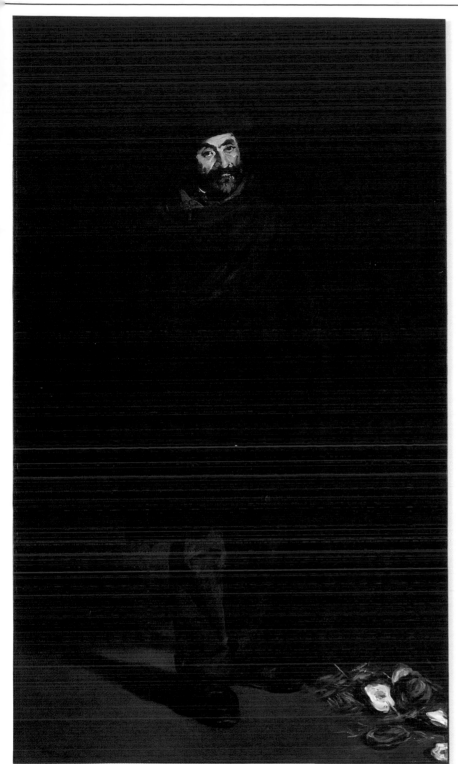

A Philosopher

1865; 73¾ x 42½ in (187.3 x 108 cm)

Manet exhibited this painting at his first one-man show at the Exposition Universelle in 1867. His work had just been rejected from the Salon of that year, so instead of attempting to exhibit at the official art pavilion, he followed Courbet's example and erected his own pavilion nearby. Characters such as this one (left) were an unwanted presence around the fabulous Exposition Universelle – Napoleon's model of society. Manet's *Philosopher*, then, was an apt addition to this exhibition by a rebel.

SOMBER COLORS

There is a remarkably limited color range used in *A Philosopher*, consisting largely of blue-gray, green-gray, and brown. Yet the painting is not gloomy or dull.

DEFT TOUCHES

Manet's treatment of space is reminiscent of his *Tragic Actor* (p. 36) and *The Fifer* (pp. 40–41). The light, feathery brushwork, however, particularly to the right of the philospher's legs, is even more loosely suggestive and abstract.

USE OF LIGHT

The philosopher, wrapped in a blanket to protect him from the cold night air, stands in the wan light, perhaps cast by a streetlight.

PREVIOUS STUDY

Manet had painted several still lifes with oysters in the previous year. He may have used one of these works as reference for this painting.

THE ABSINTHE DRINKER
1859–67; 71¼ x 41¼ in (181 x 106 cm)
Around 1867, Manet extended *The Absinthe Drinker* and added it to the other "beggar-philosopher" paintings, to complete the series. How far Manet had progressed can be seen in its cruder handling.

SHADY CARICATURE
Randon has picked up on the somewhat cloak-and-dagger appearance of *A Philosopher* (above) in his caricature for *Le Journal Amusant*, 1867. He also caricatured Manet's one-man exhibition pavilion (top right), which he labelled "The Temple of Good Taste" and *"Musée Drolatique"* ("comical museum").

MENIPPUS
Velázquez; 170½ x 37 in (639–40; 179 x 94 cm)
Velázquez's "pairing" of the ancient Greek philosophers Aesop and Menippus (the satirist) was the first time the two were linked as dual exponents of common wisdom. Whether Manet was aware of this or not, he had an exact, intuitive understanding of painting. Instead of the attributes of learned thought arranged at Menippus's feet (right), Manet's philosopher (above, left) stands near a pile of straw and discarded oyster shells. His knowing expression seems to invite comparison of these sad attributes to those of his eminent ancestor.

A misjudged masterpiece

Emile Zola said of *The Fifer*, "I do not believe it possible to obtain a more powerful effect with less complicated means." Manet had learned from Velázquez (p. 38) the power and eloquence of the solitary figure in undefined space. In *The Fifer*, he combined this knowledge with strong references to Japanese prints. The firm "outline" and bold division of flat areas of color in *The Fifer* echo the sharply delineated *ukiyo-e* ("floating world") and brightly colored *nishiki-e* woodblock prints then in circulation, by artists such as Utamaro and Kuniaki II (p. 41). These prints relied upon the drawing and skill of the artist to maintain the delicate balance between abstract and "real" space. Manet was blessed with such skill and knew instinctively the value of economy of line and brushwork.

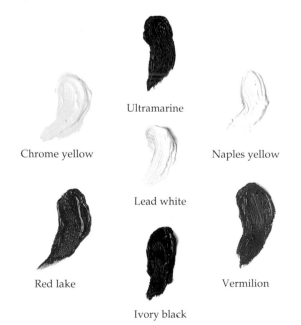

Fife

Chrome yellow

Ultramarine

Naples yellow

Lead white

Red lake

Ivory black

Vermilion

MATERIALS
The powerful effect of *The Fifer* is in large part due to an inspired use of just a few strong colors. The cool, neutral space from which the fifer emerges reinforces, by its vagueness, the solid impact of the figure, which appears in sharp focus against the unspecified "infinity" of the background. The rich black and red blocks of color in the fifer's tunic and trousers are weighted down by the areas of sharp white.

The Fifer

1866; 63 x 38½ in (160 x 98 cm)

Manet had already been criticized for his "flatness" and lack of obvious modeling, and when he submitted *The Fifer* along with *The Tragic Actor* (p. 36) to the Salon of 1866, both were rejected. This time it was not a question of "morals" but of talent: the jury considered both paintings inept. In rejecting *The Fifer* they revealed their blindness to the modern developments in painting, and to the sophistication of Manet's art.

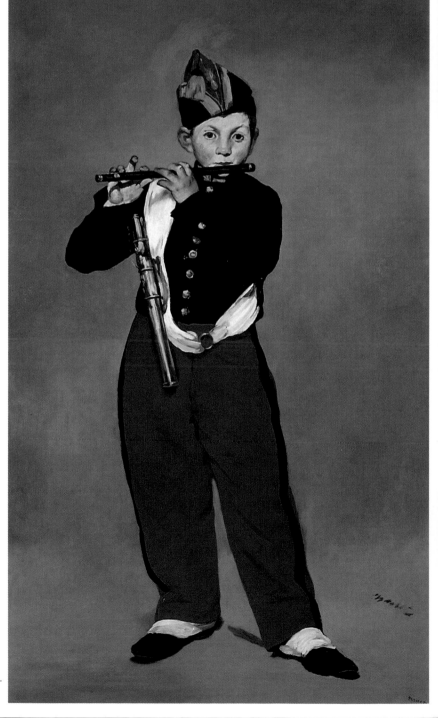

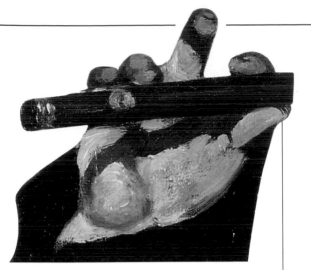

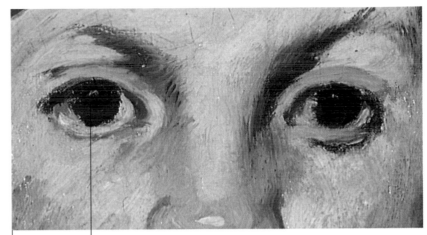

TRUE DEFINITION
The strange shape of the fifer's hand, with its dark, distorting shadow, painted without concession to artificial refinement, would have seemed simply bad painting to the jury that rejected it. The critic Paul Mantz called *The Fifer* "an amusing specimen of primitive illustration."

The slightly unfocused eyes convey the remoteness of a child's gaze

EYES OF YOUTH
Berthe Morisot (pp. 46–47) wrote: "Only Manet and the Japanese are capable of indicating a mouth, eyes, a nose in a single stroke, but so concisely that the rest of the face takes on modeling." Moreover, Manet has captured the guileless, childlike expression of the boy.

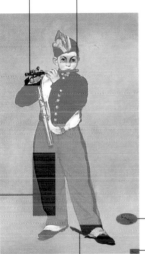

DOUBLE SIGNATURE
Manet signed *The Fifer* twice: in the bottom right-hand corner, and again, much larger, as an integral compositional device. Running parallel to the diagonal created by the fifer's foot, the signature helps reinforce the impression of solid ground.

Flat plane of red outlined in black is reminiscent of Japanese woodblock prints

BLACK AND WHITE
This very pleasing bit of painting is as much a signature for Manet's style as is his name. The spat is sculpted out of thick, unmixed white paint, applied back and forth, describing the form beneath. *The Fifer* has undoubtedly darkened with age, and, like *Olympia* (pp. 28–29), lost some of its original raw impact. It is nevertheless still startling in its freshness of color and handling. Manet loved black and, unlike the Impressionists, valued it highly as a color. Recent analysis has shown that he mixed pigments such as cobalt blue, yellow earth, and chrome orange with ivory black, to create tones in the black.

Gray background evokes the smoke of a battleground

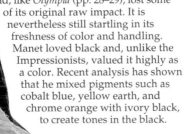

FLAT COLOR
With very few shadows and almost no modeling, the fifer's baggy trousers would indeed appear flat and empty, were it not for the black strips on each leg – skillfully applied to suggest form and volume.

Shadow "anchors" the image in indefinite space and helps to define the floor plane

Sculpted application of white paint gives solid form to the spat

The Maximilian affair

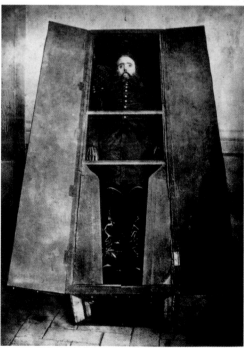

Reconstructed
fragments of
original painting

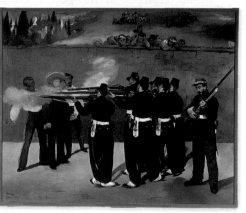

THE EXECUTION OF EMPEROR MAXIMILIAN
1867; 77¼ x 102¼ in (196 x 259.8 cm)
Manet's first version is closest of all to Goya's impassioned drama (below) and is more fiery and unrestrained than subsequent portrayals.

MANET'S CONTEMPT FOR history painting did not mean that he avoided contemporary political issues. He was deeply affected by an extraordinary series of events in Mexico: the Maximilian affair. In 1860, a revolutionary, Benito Juárez, overthrew General Miguel Miramón to become President of Mexico. He refused to acknowledge Mexico's debts to France, Spain, and Britain, and in 1861 the three nations invaded Mexico. Spain and Britain soon withdrew, but Napoleon III had other plans: in 1863, French troops took Mexico City and installed the Austrian Archduke Maximilian as emperor. Maintaining French rule in Mexico, however, was a difficult, costly operation, involving 40,000 French soldiers. In 1867, Napoleon withdrew all his troops, abandoning Maximilian to his inevitable fate. Within three months, Maximilian was captured by Juárez's guerillas, and executed.

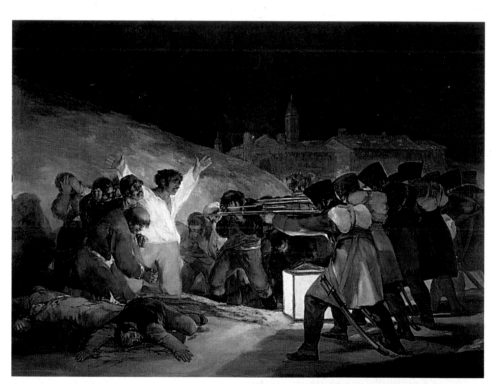

THE THIRD OF MAY, 1808
Francisco Goya; 1814; 105½ x 136½ in (268 x 347 cm)
Manet's paintings of the execution of Maximilian were largely inspired by Goya's *The Third of May*, depicting atrocities committed by the French army in Spain in 1808.

THE EXECUTION OF EMPEROR MAXIMILIAN
1868–69; 99¼ x 119 in (252 x 302 cm)
Full details of the events in Mexico did not reach Paris all at once. The first version Manet painted of the incident (top), depicting the firing squad in traditional Mexican uniform, accords with the public's initial horror at Juárez's actions, and the blame lies firmly with the Mexicans. This (right) is Manet's largest version and the last of the four that he painted in the series.

RELICS OF A VIOLENT DEATH
After the execution of Archduke Maximilian, his remains were displayed in an open coffin (above). His eyes were replaced with black marble and vital organs preserved in compartments near his legs. The shirt worn by Maximilian at his execution (right) was photographed, showing where the bullets entered his body. Fiercely loyal to his adopted country, he died declaring, "May my blood flow for the good of this land. Viva Mexico!"

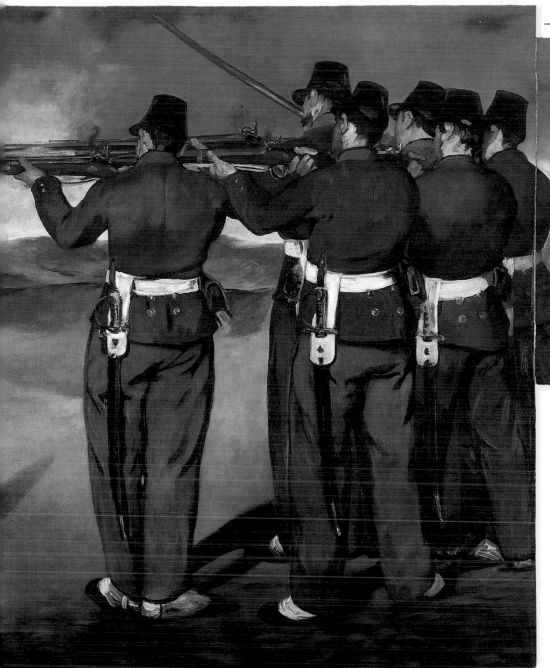

(p. 27 and p. 33)

A FRAGMENTED PAINTING

There is a remarkable story behind the present condition of this painting. After Manet's death, Léon Leenhoff, hoping to make it more salable, cut out the soldier (above). It was bought by Degas (p. 27 and p. 33), who was told that the rest of the painting was destroyed by accident. When other fragments turned up at Degas' own picture restorer, he was furious, saying, "You're going to sell me that. And you'll go back to Mme. Manet and tell her I want the legs of the sergeant that are missing from my bit, as well as what's missing from yours." One can imagine his reaction on discovering that Léon had used them to light a fire.

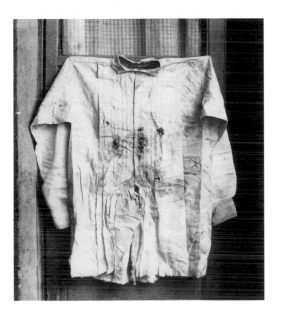

The Execution of Emperor Maximilian

1867–68; 76 x 111¾ in (193 x 284 cm)

In this version the action takes place in broad daylight, in the open country, with the firing squad at point-blank range. This work of cold brutality has a shock power akin to photojournalism. It has an almost amoral quality, making it one of the most disturbing images of its kind. Through his controlled detachment, and by placing the firing squad in French, not Mexican, uniform, Manet subtly condemns Napoleon's own indifference to the fate of Maximilian. A truly political work, it was never exhibited in Manet's lifetime, and his later lithograph of the painting was confiscated by the government.

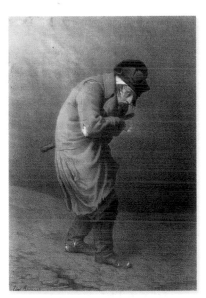

THE END OF A LEGEND

Napoleon's ruthless action was a disgrace and marked the beginning of the end for the Second Empire, which finally collapsed during the Franco-Prussian War (1870–71; pp. 46–47).

The fall of Paris

IN JULY 1870, FRANCE DECLARED WAR on Prussia. Just two months later, Napoleon III surrendered his troops at Sedan in northeast France. When news reached Paris, angry mobs forced the collapse of the ailing empire, and the Third French Republic was proclaimed. The war resumed and in two weeks Paris was under siege from the Prussian army. Manet had joined the National Guard and sent his family to the country. Four months later Paris had surrendered, and Manet was free to rejoin his family. When he returned to Paris in May 1871, it was in the depths of civil war. The radical Republicans and socialists had refused to accept the government's terms of surrender, and had elected a municipal council, the Commune. The wars affected Manet profoundly, and he later suffered bouts of depression.

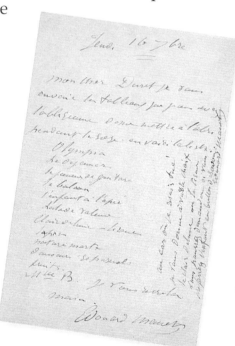

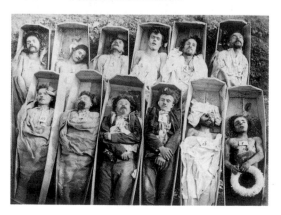

"UNE PETROLEUSE"
This powerful image of one of the notorious petrol-bombers reflects the active role taken by women during the conflicts of the Paris Commune.

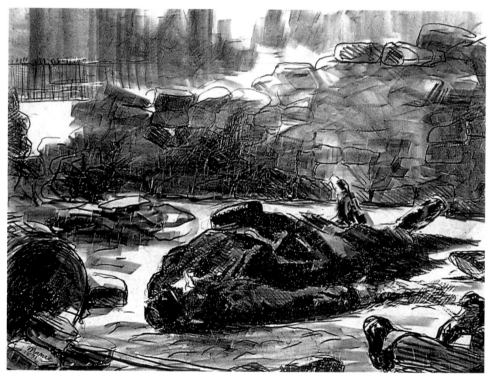

LETTER TO DURET
During the siege Manet had closed his studio at the rue Guyot and entrusted his friend Théodore Duret with the safekeeping of its contents. In a letter to Duret in which he lists the paintings to be stored by his friend, Manet adds a touching footnote: "In case I should die, I would like you to keep *your* choice of *Moonlight* or *The Reader*, or, if you prefer, you can ask for the *Boy with the Soap Bubbles* [p. 34]."

A SPONTANEOUS IMAGE
According to Duret, the drawing for this lithograph, entitled *Civil War* (1871–73), was done on the spot, at a scene of carnage Manet happened upon "at the corner of the rue de l'Arcade and the Boulevard Malsherbes." Whether or not this is true, it remains an enduringly tragic image and is markedly similar to Manet's *Dead Toreador* of 1863 (p. 19). Manet joined the war as an artilleryman but was soon made a lieutenant. He was never involved in combat and found life as a soldier "boring and sad." In a letter to Suzanne, written four months into the siege when he was cold, miserable, and suffering from flu, he described "doing your portrait from a photograph on a little piece of ivory. I long to see you again, my poor Suzanne, and don't know what to do without you."

DEAD COMMUNARDS
These corpses, lined up in makeshift coffins, were victims of the terrible fighting that took place in the streets of Paris between the Communards and the federal army. The Communards eventually succumbed – during what became known as "the Bloody Week" – to the larger force. By the end of the conflict, at least 20,000 Parisian citizens had been massacred by the 70,000 troops ordered into the city to suppress the Commune.

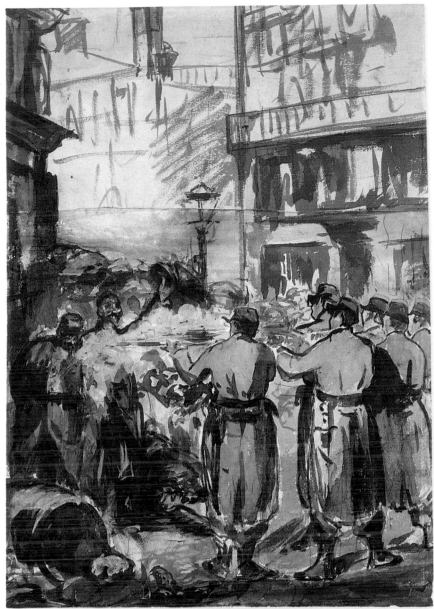

HARD TIMES
The siege was a time of great hardship for the inhabitants of Paris, with living conditions worsening daily and people dying from starvation and disease. This satirical drawing, "The line for rat meat," depicts bourgeois citizens on their hands and knees, brought low by the need for food. When the siege was over, Manet wrote: "They are dying of hunger and even now there is great distress."

A SOLDIER'S WORDS
Manet wrote frequently to his wife, Suzanne, from besieged Paris, and many letters were sent by hot-air balloon, the only postal service available. In the letter below, Manet expresses a soldier's weariness and cynicism about the cause of the Franco-Prussian war. He signs off: "Good-bye, my dear Suzanne, I embrace you lovingly and would give Alsace and Lorraine to be with you."

THE BARRICADE *above*
1871; 18¼ x 12¾ in (46.2 x 32.5 cm); pencil, ink wash, watercolor, and gouache
Manet had planned a large painting, *The Barricade*, for the 1872 Salon, based on his *Execution of Maximilian* (p. 42 and below). This execution scene is a vertical reworking of the originally horizontal composition, and Manet added a piece of paper to extend the composition.

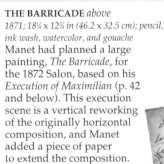

THE BARRICADE *left*
The reverse side of Manet's *The Barricade* shows the original tracing he made of his 1868 lithograph *The Execution of Maximilian*. His next step was to turn the paper over and retrace the image, which was then the starting point for *The Barricade*.

45

Manet and Morisot

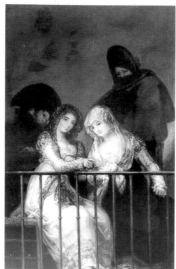

LAS MANOLAS AU BALCON
Goya; 1812; 76¾ x 49½ in (194.8 x 125.7 cm)
Manet saw this painting when he visited Spain in 1865, and would have seen it as an engraving in one of the many publications on Spanish art then circulating in Paris.

IN THE PERIOD between the Maximilian affair (pp. 42–43) and Manet's involvement in the Paris Commune (pp. 44–45), he painted *The Balcony*. He had recently met the young painter Berthe Morisot, and *The Balcony* was the first of many paintings Manet made of her. Once again Manet makes reference to the old masters, this time paying tribute to another of the Spanish giants, Francisco de Goya. Manet has borrowed Goya's front-on compositional device; but where there is a mood of intimacy and intrigue between the characters on Goya's balcony, Manet has created a very Parisian, characteristically aloof scenario. When Manet exhibited *The Balcony* at the Salon of 1869, it was met with considerable bewilderment. Moreover, the painting's bold colors, which seemed violent then – and still have a certain rawness today – upset the critics.

ACCOMPANYING MESSAGE
The metal plate on Manet's gift to Morisot bears a direct transcription of his letter: "Don't be surprised at the arrival of a new type of easel that is very useful for pastels. It is my modest New Year's gift."

A GIFT FOR MORISOT
Manet sent this pastel easel to Berthe Morisot on December 28, 1880. He was producing a great many pastels himself at this time. At first, Manet was largely influenced by Degas in taking up pastel painting, and later, when his health was deteriorating, he found it a less demanding medium than oil.

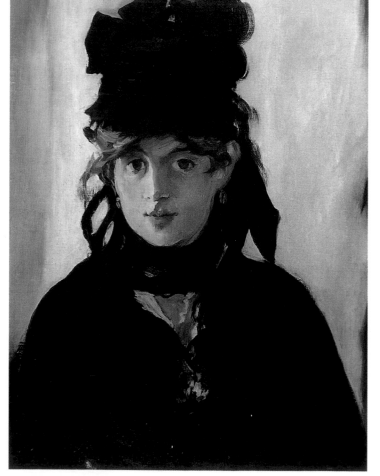

BERTHE MORISOT WITH A BUNCH OF VIOLETS
1872; 21¾ x 15 in (55 x 38 cm)
This stunning portrait of Berthe Morisot is one of Manet's finest paintings, and, perhaps in acknowledgment of this, he painted the little bunch of violets for her. They first met in the Louvre, where she was copying a Rubens, and became lifelong friends. There seems to have been some degree of mutual infatuation over the course of their relationship, but this may have been no more than enthusiasm for each other's company. The Manet and Morisot households became permanently connected, however, when Berthe married Manet's younger brother, Eugène, in 1874.

WOMAN AND CHILD
Berthe Morisot;
specification unknown
Morisot owed a certain debt to Manet in the development of her relaxed brushwork; she, in turn, having adopted the light, "synthesized" color of 1870s' Impressionism, influenced Manet's palette. Her paintings of gardens may also have led him to tackle the same subject later.

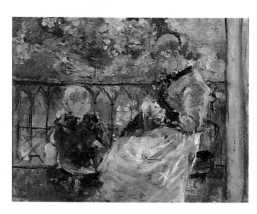

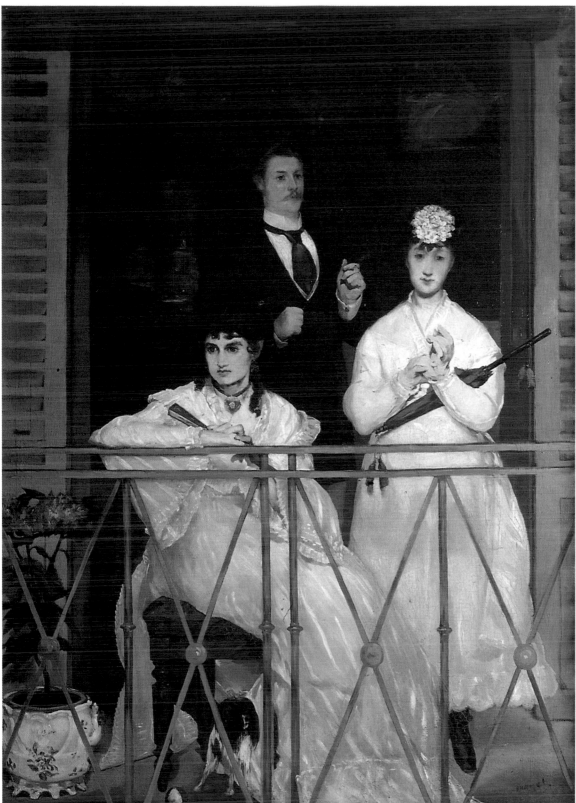

CRITICAL CARTOON
This caricature, by Cham, was accompanied by the warning: "Do close that window! What I'm telling you, M. Manet, is for your own good."

NOTE OF BLUE
Prominent amid the intensely green-dominated color harmonies is the gentleman's silk cravat. Its beetle-wing, iridescent blue is utterly dissonant from the rest of the painting. It works as one of Manet's isolated, often quirky, "notes" of color.

WEARY MODELS
All the models who posed for the lengthy, tiring sittings Manet required for *The Balcony* were friends of his: Antoine Guillemet, Fanny Claus, Berthe Morisot, and, in the background, carrying a tea urn, Léon Leenhoff (p. 26).

SURFACE QUALITIES
The heavily built-up paint surface of Morisot's portrait is proportionate to the intensity of her expression; conversely, Fanny Claus's vague, indeterminate expression is rendered almost as a sketch.

FROZEN ACTION
Critics were at a loss to interpret the meaning of *The Balcony*. One woman puts on her gloves and is about to leave, the other is absorbed by something in the street, while the man stands as though under a spell.

The Balcony

1868–69; 66½ x 49¼ in (169 x 125 cm)

Manet struggled with this painting and was nervous about the response it would get at the Salon. Morisot recalled, "He was laughing, then he had a worried look, assuring everyone that his picture was very bad, and adding in the same breath that it would be a great success."

THE LEADING FEMALE IMPRESSIONIST
Berthe Morisot had taken lessons early on from the aging landscape painter Camille Corot, and she later became a leading member of the Impressionists. Naturally moody and sensitive, she struggled with depression, and she bitterly resented "the injustice of fate" that, in making her a woman, held her ransom to the conventions of the day.

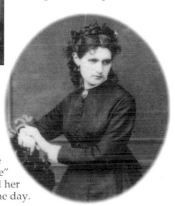

Detachment and intimacy

WE KNOW FROM DOCUMENTARY evidence that Manet was a popular socialite; there are many accounts of his charm, gaiety, and physical appeal from his friends and acquaintances. Stéphane Mallarmé called him "goat-footed, a virile innocence in beige overcoat; beard and thin blond hair, graying with wit." It seems his passion for the city and its nightlife, and his curiosity for every new spectacle the city had to offer, was tireless. Yet, for all this superficial gaiety, there runs through the whole of Manet's work a seam of doubt, and a form of emotional paralysis. It suggests that underneath his suave public exterior there existed a very different, private character that found expression in his paintings. The painter Ernest-Pierre Prins (widower of Fanny Claus, p. 47) wrote, after Manet's death, of the "underlying neurosis which he harbored, for all his outward insouciance." Contrary to his image of smiling confidence, Manet was assailed by self-doubt: "Abuses rain upon me like hail ... obviously, somebody is in the wrong."

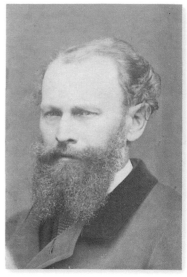

A VIEW OF MANET
"The soul of generosity and kindness, he was apt to be ironical in speech, often cruel. He had a formidable wit, at once trenchant and crushing." – *Armand Silvestre*

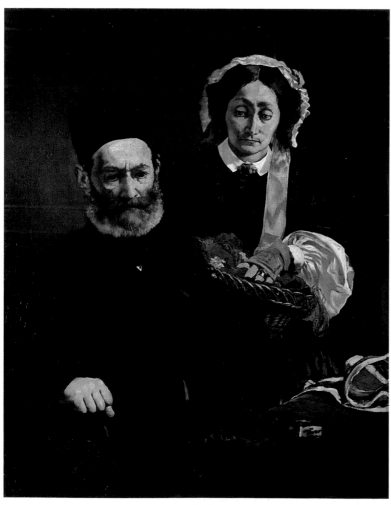

PORTRAIT OF M. AND MME. MANET
1860; 43¼ x 35½ in (110 x 90 cm)
It is strange that the inability of Manet's characters to engage the viewer, or communicate with one another, should exist in paintings where he had chosen models from among his close family and friends (p. 47). This early manifestation of anxiety and isolation – a portrait of Manet's mother and father – makes it tempting to look for clues to the artist's emotional development.

IN THE CONSERVATORY
1879; 45¼ x 59 in (115 x 150 cm)
In Manet's portrait of the fashionable young couple M. and Mme. Jules Guillemet, the American "beauty" and her husband seem artificial, icily remote from each other. With their newlywed status, one would expect to see a warmer, more intimate mood.

AT THE CAFE-CONCERT
1878; 18 x 15 in (46 x 38 cm)
At the Café-Concert is a sensitive portrayal of loneliness and isolation. In an atmosphere of noise, heat, and smoke, the main characters seem lost in themselves. They look in opposite directions, making no eye contact. The *café-concert* (pp. 56–57) attracted members of all classes, but the close proximity of the top-hatted gentleman to the working girl, if anything, increases the sense of isolation.

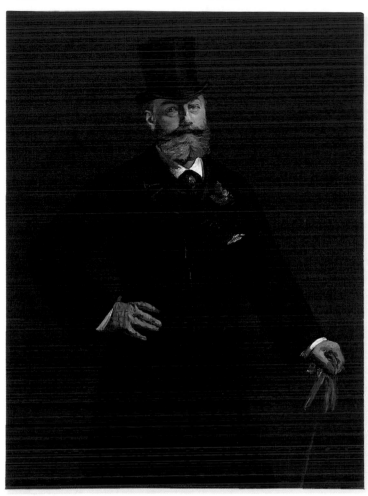

PORTRAIT OF ANTONIN PROUST
1880; 60 x 37¾ in (129.5 x 95.9 cm)
According to Proust, Manet intended to paint his portrait, "on unprepared white canvas, in a single sitting." And Manet did virtually complete it in one sitting: "After using up seven or eight canvases, the portrait came all at once." At the 1880 Salon, many critics complained that it was unfinished, but it also received enthusiastic reviews, even from Paul Mantz (p. 41): "The painter has given his model a great deal of swagger and a gallant air which is indeed that of Antonin Proust. The whole face is alive and the color harmony, dominated by a gray blue, is sober, distinguished, and elegant."

A LOYAL FRIEND
The only source for some of Manet's earliest sayings is Antonin Proust's *Souvenirs de Manet*, first published in 1897. Manet and Proust were schoolboys (pp. 6–7) and students (pp. 10–11) together and they remained lifelong friends. Proust's "souvenirs" are unfailingly loyal (sometimes even biased or inaccurate) reminiscences of their friendship which offer a very human account of the artist.

Antonin Proust

Message written on back of entertainer's card

CONFIDENT CHARM
In this odd "calling card" Manet makes a joke at his own expense, perhaps in the hope of endearing himself to the beautiful New York entertainer: "Enter! Enter! See the famous pictures of the famous painter ... Edouard Manet."

LETTER OF THANKS
In an article published in 1874, Mallarmé defended Manet and the artist sent him thanks: "If I had a few supporters like you, I wouldn't give a damn about the jury. Yours ever, Ed. Manet."

PORTRAIT OF STEPHANE MALLARME
1876; 10¾ x 14¼ in (27 x 36 cm)
Manet first met the poet Stéphane Mallarmé in 1873, when he was still an unknown English teacher, and they became very close friends. Manet illustrated Mallarmé's own works (p. 37) as well as his translations of Edgar Allan Poe's poems. This intimate portrait reveals something of their intense friendship. After Manet's death, his widow wrote to Mallarmé: "You really were his best friend, and he loved you dearly."

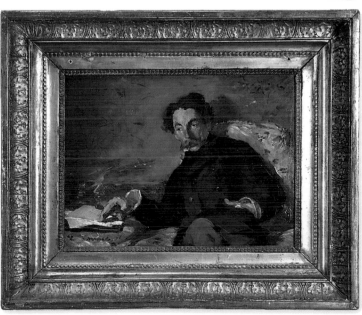

The respectable rebel

FRONT PAGE EXPOSURE
This journal illustrates *Le Bon Bock*'s popularity, and includes Manet's unpopular work of the 1881 Salon and controversial Legion of Honor medal awarded to him that year (p. 58).

A CENSORED WORK
Manet's lithograph, *Polichinelle* (right), was banned for its likeness to President MacMahon.

With his painting *Le Bon Bock*, Manet at last began to receive the recognition he had craved from the Salons for 12 years. It was his first real success with the critics since the honorable mention he received for *The Spanish Singer* (pp. 18–19) at the Salon of 1861, and it was popular with the public. Manet had already achieved considerable fame, but this new attention signified that the establishment he had battled for so long had finally come to accept him as an important figure. Conversely, members of his own artistic circle, and the young radicals who regarded Manet as the leader in their attack on the establishment, saw *Le Bon Bock* as something of a compromise, and Albert Wolff, the notorious critic for *Le Figaro*, accused Manet of "watering his beer." It is ironic, then, that in 1874, the same year as the first Impressionist exhibition, which provoked much scandal, Manet produced *Polichinelle*, an image that the government immediately banned.

THE TOPER
Frans Hals; 1628–30; 32 x 26¼ in (81 x 66.5 cm)
Manet visited Holland again in 1872. He studied the work of the painter Frans Hals, whose *The Toper* was the inspiration for *Le Bon Bock*. Manet has preserved the same spirit of smiling joviality in *Le Bon Bock*, a portrait of an engraver, Emile Bellot.

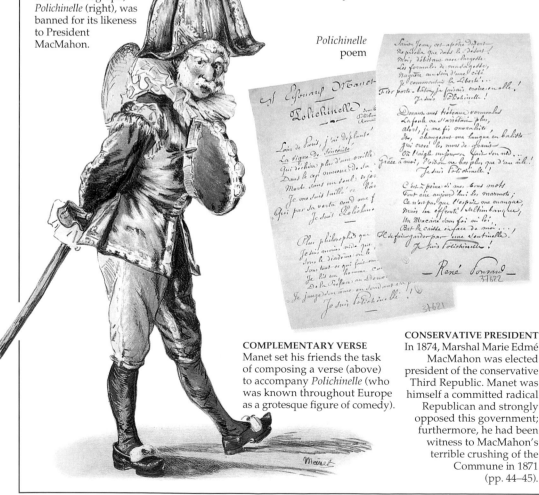

Polichinelle poem

COMPLEMENTARY VERSE
Manet set his friends the task of composing a verse (above) to accompany *Polichinelle* (who was known throughout Europe as a grotesque figure of comedy).

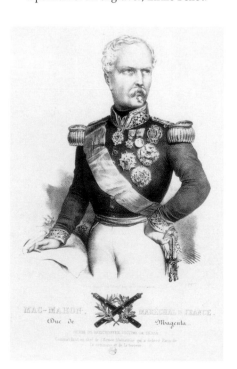

CONSERVATIVE PRESIDENT
In 1874, Marshal Marie Edmé MacMahon was elected president of the conservative Third Republic. Manet was himself a committed radical Republican and strongly opposed this government; furthermore, he had been witness to MacMahon's terrible crushing of the Commune in 1871 (pp. 44–45).

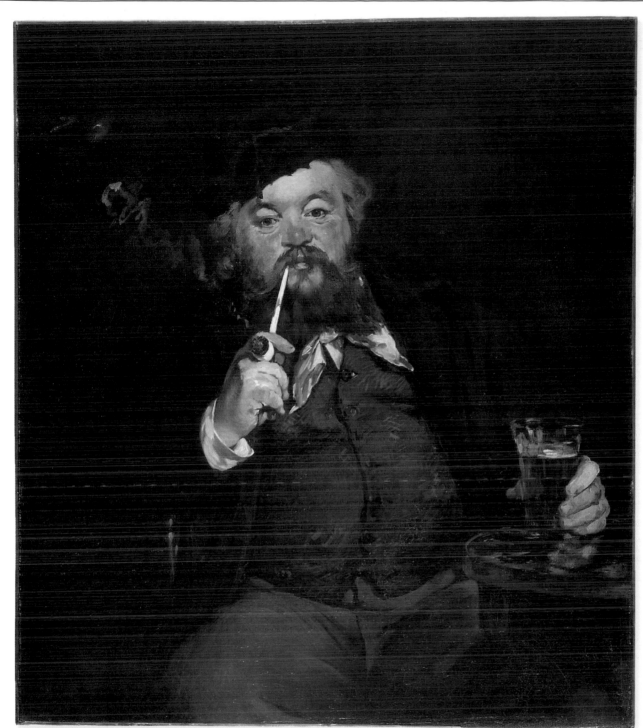

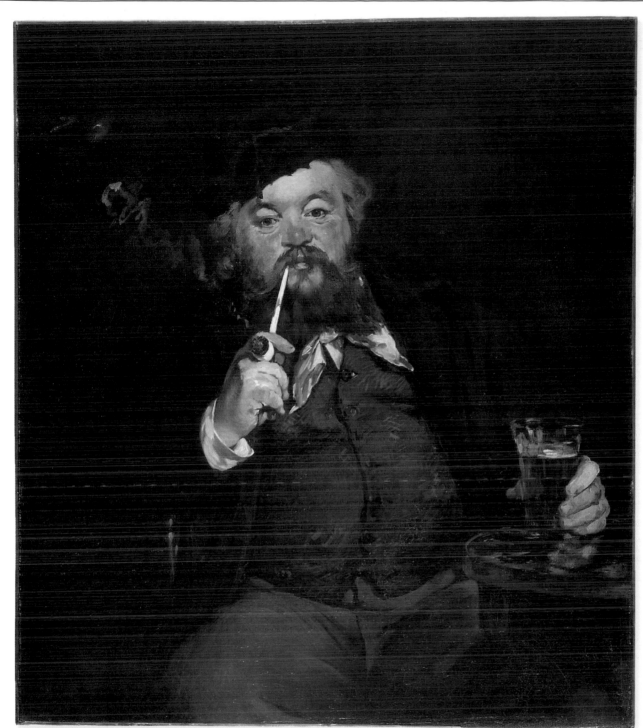

THE SPIRIT OF HALS
The ruddy, apple-like complexion of the engraver Bellot is very much in the spirit of Frans Hals's rosy-faced wenches and carousers, and it is painted with a bravura to match.

CARICATURE
Second to *Olympia*, *Le Bon Bock* was the subject of more caricatures than any other Manet painting. This time, however, after initially ridiculing the painting, the cartoons began to reflect its popularity.

MASTER'S IMPACT
Although this painting makes reference to Hals, with its warm, gray tonality and subtle range of browns, it also summons up the paintings of Velázquez – Manet's most enduring influence.

THE CRITICS
"What a hard, flat, confused, uncertain touch!" Criticisms like this one, from Ernest Duvergier de Hauranne in 1873, are hard to understand when confronted with the actual painting.

Le Bon Bock

1873; 37¼ x 32¾ in (94 x 83 cm)

Because *Le Bon Bock* was directly reminiscent of Dutch art (unlike Manet's previous irreverent references to some old masters), he received praise from the most conservative of critics. The annual Salon review, *Revue des Deux Mondes*, which had completely ignored Manet throughout his career (maintaining a haughty silence even through the controversial years 1863 and 1865), now awarded him lengthy, serious critical attention.

ACCOMPANYING POEM
Carjat wrote a poem to accompany Manet's *Le Bon Bock*. This character has witnessed all the horrors of the Paris Commune, yet Carjat concedes that life goes on – with pleasures such as food and, above all, a good beer.

Clay pipe

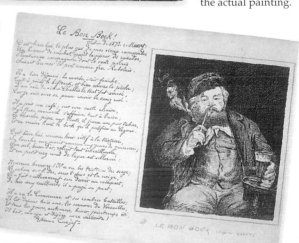

Manet or Monet?

"WHO IS THIS MONET WHOSE name sounds just like mine and who is taking advantage of my notoriety?" This was Manet's initial reaction to the hitherto unknown Monet, recorded by Théodore Duret in 1865. He was irritated by the attention the young painter was receiving and exasperated by the ensuing confusion over their names. Manet was already regarded as a modern master by the young avant-garde, and as their leader in the attack on stale academic values. Manet and Monet were to become good friends (pp. 54–55), and although they admired each other's work, their artistic ideals and aspirations were very different. Though Manet's palette lightened in succeeding years, and he adopted a more naturalistic approach under the influence of Impressionism, he remained essentially a studio painter.

MANET'S OUTLOOK
The first Impressionist exhibition took place in 1874 at the studio of the photographer Félix Nadar (left) in Paris. Manet was invited, but declined to take part in the exhibition. Reluctant to be seen as part of any group, and perhaps not wishing to tarnish his success at the previous year's Salon (pp. 50–51) by publicly associating with the young "unknowns," he continued to submit work to the Salon.

IMPRESSION, SUNRISE
Claude Monet; 1873; 19 x 24¼ in (48 x 63 cm)
At the Salon of 1866, when Manet's paintings had been rejected and Monet's accepted, the critic Félix Jahyer was spiteful enough to write: "Since Manet has been politely shown to the door, Monet has been chosen as leader of this brilliant school." It wasn't until eight years later, at the first group exhibition, that the new school gained a name. Journalist and critic Louis Leroy named it Impressionism after Monet's much-maligned painting (right).

MONET IN HIS STUDIO BOAT
1874; 31½ x 35½ in (80 x 98 cm)
Manet shows us Monet in deep concentration, at work on one of over 150 landscapes he painted in his six years at Argenteuil. Monet constructed his floating studio in imitation of another French Impressionist, Charles-François Daubigny.

CLAUDE MONET
This wonderfully concise brush and ink portrait of Monet was done during the summer Manet spent painting in Argenteuil with Monet (pp. 54–55). Monet is wearing his painting hat, as in his portrait (left), but there the brim is turned down to shade his eyes.

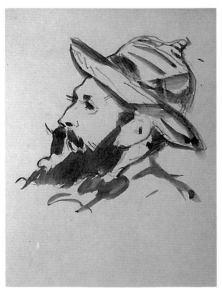

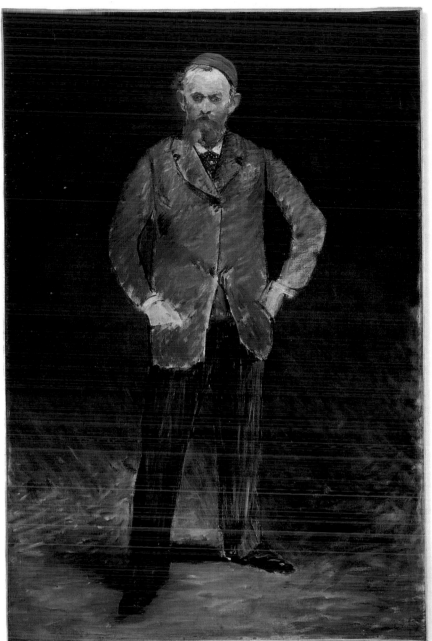

SELF-PORTRAIT WITH SKULL CAP
1878; 37 x 25¼ in (94 x 64 cm)
This self-portrait was painted the same year Manet's incurable illness was first diagnosed. The defiant pride with which he confronts the viewer is belied by the anxious expression in his eyes, as his thoughts turn inward, and by the signs of illness visible in his face and stiff pose.

A STUDIO IN THE BATIGNOLLES
Henri Fantin-Latour; 1870;
80¼ x 107¾ in (204 x 273.5 cm)
In his group portrait of Manet at work in his studio, surrounded by admiring onlookers that include Zola, Monet, and Astruc, Fantin-Latour acknowledges Manet's position as leader of the avant-garde. Renoir (third from the left) said of him, "Manet was as important to us as Cimabue and Giotto were to the Italian Renaissance."

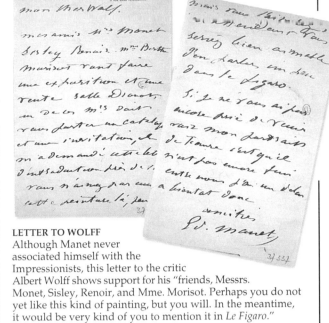

LETTER TO WOLFF
Although Manet never associated himself with the Impressionists, this letter to the critic Albert Wolff shows support for his "friends, Messrs. Monet, Sisley, Renoir, and Mme. Morisot. Perhaps you do not yet like this kind of painting, but you will. In the meantime, it would be very kind of you to mention it in *Le Figaro*."

ARTIST OR CHRIST?
The cartoonists seized on the reverential tone of Fantin-Latour's portrait (below): Bertall's cartoon is a parody of Christ teaching his apostles.

KING OF THE IMPRESSIONISTS
As champion of the avant-garde, Manet was seen as representative of the new or radical forms of painting, and the term "Impressionist" was applied to many diverse styles deviating from the norm. Despite such confusion, Manet stands alone; he cannot be regarded as a true Impressionist.

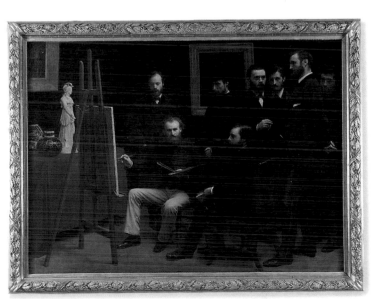

An Impressionist landscape

MANET SPENT THE SUMMER OF 1874 at his family home in Gennevilliers and painted alongside Claude Monet (pp. 52–53), who lived on the opposite bank of the Seine at Argenteuil. He particularly admired the work of the younger painter, whose influence we can see in this landscape – Manet's most Impressionistic work. At the beginning of the 1870s Manet had begun to paint more outdoors, and these paintings marked the start of a less "contrived," more naturalistic depiction of modern life. However, besides a small body of paintings that were loosely Impressionist in their execution and subject matter, the Impressionists' influence on Manet is most marked in the consequent lightening of his palette.

Cobalt blue Ultramarine blue Ivory black

Lead white Yellow ochre Chrome orange

Viridian green Cobalt violet Red lake

MATERIALS

The Impressionist palette included many recently developed synthetic pigments. Proust recalled Manet saying, "I have finally discovered the true color of the atmosphere. It's violet ... Three years from now everyone will work in violet." Cobalt violet first appeared in 1859 and was included in Monet's palette as early as 1869. But the pure mauve pigment was not widely used until the 1870s; Manet has used it extensively here, especially in his painting of the water. Cobalt blue, sometimes known as Dresden blue, had been invented by French chemist L.J. Thénard in 1802.

Portable paint box

The Seine at Argenteuil

1874; 24½ x 40½ in (62 x 103 cm)

In this quiet painting of Monet's first wife, Camille, and their son Jean, Manet has subordinated the figures in favor of the whole. It has an uncharacteristic incidental quality, and the figures seem unaware of the spectator. This is relatively rare in Manet's work, where psychological tension of some form is often present and figures possess an undeniable self-consciousness.

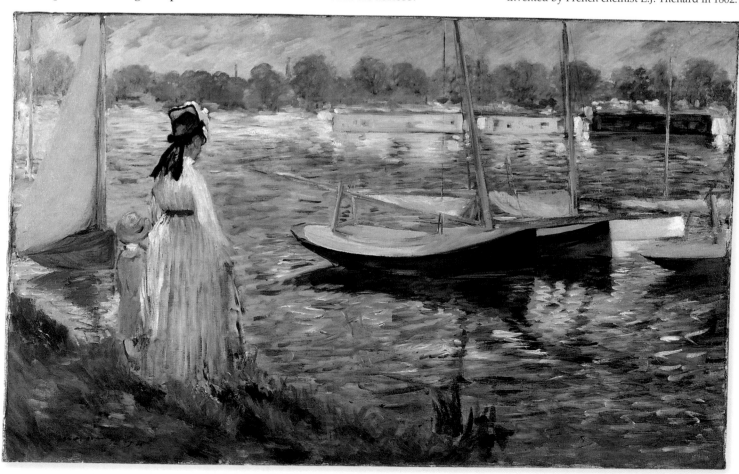

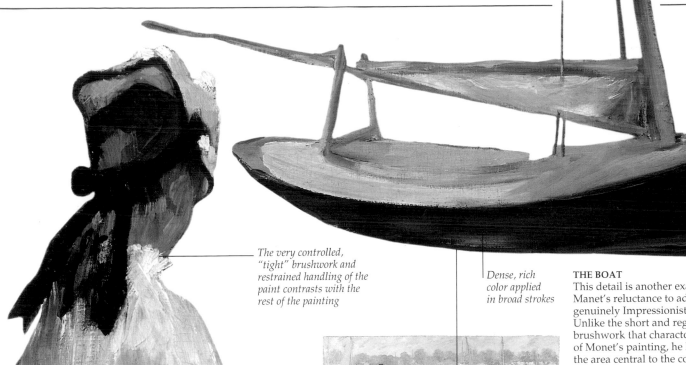

The very controlled, "tight" brushwork and restrained handling of the paint contrasts with the rest of the painting

Dense, rich color applied in broad strokes

THE BOAT
This detail is another example of Manet's reluctance to adopt a genuinely Impressionist technique. Unlike the short and regular-sized brushwork that characterizes much of Monet's painting, he has painted the area central to the composition in long modulated strokes and unbroken color. This tendency of Manet's to select from the scene and emphasize certain elements contradicts the Impressionists' almost egalitarian approach to the landscape: in their style, one element is rendered with as much or as little importance as the next.

ATTENTION TO DETAIL
Even in his most Impressionist painting, Manet did not abandon his beloved black. Although the figures are subordinate to the landscape, there is still a focal point in the black ribbons of Camille's bonnet. We can see Manet's unceasing curiosity about the accessories of modern living in his careful attention to the rather bizarre structure of the bonnet, similar to his wife's (p. 27).

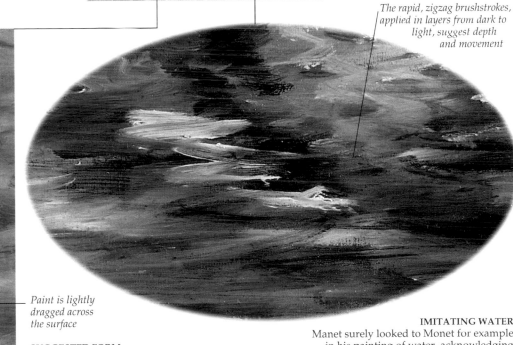

The rapid, zigzag brushstrokes, applied in layers from dark to light, suggest depth and movement

Paint is lightly dragged across the surface

SUGGESTED FORM
Camille's hand is barely suggested in a single broad brushmark of warm red. The paint is dragged over the surface, allowing cooler colors beneath to show through – neutralizing the red in this cool, blue-dominated picture. The stick, or umbrella, on which she leans consists of three swift, softly applied strokes of black that disappear into the grass. Her dress is entirely composed of single brushstrokes reflecting either the dark green of the grass and cool blues of the water in the lower half, or the warm light falling on the upper half.

IMITATING WATER
Manet surely looked to Monet for example in his painting of water, acknowledging Monet's "understanding of its mystery and all its moods," and calling him the "Raphael of water." In this detail, we can see how, with fast, zigzag brushstrokes, Manet has imitated the action of rippling water, employing complementary colors of cobalt blue and violet for the water, against chrome orange for the reflection on the boat's rigging. However, his use of complementary colors is not schematic, nor consistent with the general Impressionist color theory.

Reign of the courtesan

"UNE LOGE DU COCOTTES"
This popular illustration of two fashionable prostitutes – very décolleté – seated in a box at the theater, shows the kind of lifestyle available to the successful courtesan.

HAUSSMANN'S MODERNIZATION of Paris (pp. 14 and 38) had altered the structure of the Parisian way of life. The boulevards had now become venues for daily entertainment for the pleasure-seeking bourgeoisie. With strolling now a popular activity and families frequenting the cafés in search of the "vulgar spectacle" of the café-concert, the writer Maxime du Camp noted: "One does not know nowadays … if it's honest women who are dressed like whores or whores who are dressed like honest women." Increasing prostitution had become more visible since the great changes, and was a popular subject for artists and writers. Manet had sealed his notoriety with his earlier portrayal of a prostitute (pp. 28–29) and returned to the theme several times. With *Nana*, a witty image of prostitution, Manet was brazenly challenging the public and critics by portraying this particular scene on such a daring and irreverent scale.

JAPANESE PRINT
The stylized form of this print of a courtesan by Soken Yamaguchi is oddly paralleled by Manet's curvaceous *Nana* (below).

STAGE PLAY OF NANA
The enormous popularity of Zola's novel led to the staging of a theater production at the Théâtre de l'Ambigu in 1881. Elaborate sets helped to make the play a success.

THE POPULARITY OF NANA
Emile Zola's novel Nana provoked a storm of protest and excited gossip, and when the novel went on sale in 1880, it completely sold out: 55,000 copies were purchased in the first day. This poem by Alfred Barbou (right) is a celebration of *Nana's* spirit.

INITIAL MANUSCRIPT
Nana (left) was one of 20 novels in which Zola plotted the lives of one family. Although the title of Manet's *Nana* (right) is derived from Zola, the painting was completed before the book's release. Manet's *Nana* corresponds with her description in Zola's preceding novel, *L'Assommoir*.

NANA
1877; 60¾ x 45¼ in (154 x 115 cm)
Manet's return to the theme of prostitution (pp. 28–29) was a departure from his previous reliance on the old masters. Here is a contemporary scenario of a half-dressed courtesan who, presenting a smiling face to the viewer, seems very much in control of the situation. Her "protector," however, sits rigidly at the edge of the canvas, powerless. *Nana*, seen as immoral, was rejected from the 1877 Salon.

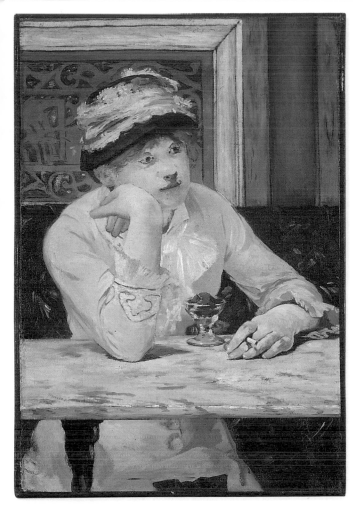

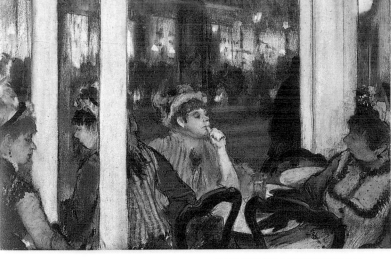

WOMEN ON A CAFE TERRACE
Edgar Degas; 1877; 16¼ x 23¾ in (41 x 60 cm); pastel on monotype
Many of Degas' intimate pastels of prostitutes tended to portray the poorer, uglier side of prostitution. This pastel of women plying their trade is closer to expressing the grim reality of their harsh existence than Manet's humorous *Nana* (far left) or his gentle, subtle work, *The Plum*.

ON THE BOULEVARD
In 1860, the Goncourt brothers, commentators on contemporary Parisian life, wrote: "Our Paris, the Paris where we were born, is passing away. Its passing is not material but moral. Social life is going through a great evolution which is beginning. I see women, children, households, families in this café. The interior is passing away."

Plum glass

THE PLUM
1878; 29 x 19¼ in (74 x 49 cm)
In this portrait of boredom Manet shows another, less frivolous, world of the prostitute. As a woman alone in a café at night, her role is ambiguous: she may be one of the many "hidden" prostitutes, poor girls forced to supplement their mean existence. Her posture and distracted gaze sum up her lonely position, and the uneaten plum and unlit cigarette are indications of her poverty.

Originally one painting joined here

AT THE CAFE *right*
1878; 30¼ x 32¾ in (77 x 83 cm)
CORNER OF A CAFE-CONCERT
far right; 1879; 38½ x 31 in (98 x 79 cm)
These two café scenes started life as one canvas, a painting that Manet began in 1878 and originally titled *Café-Concert de Reichshoffen*. However, Manet cut the canvas into two pieces before finishing it (pp. 19 and 26). The left section became *At the Café*, and the right section, which Manet extended with a 7½-in (19-cm) strip of canvas, became *Corner of a Café-Concert*.

When the two sections are brought together, we are able to see how the two now very different paintings correspond to the original design.

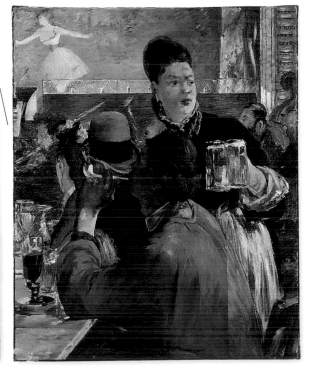

The final masterpiece

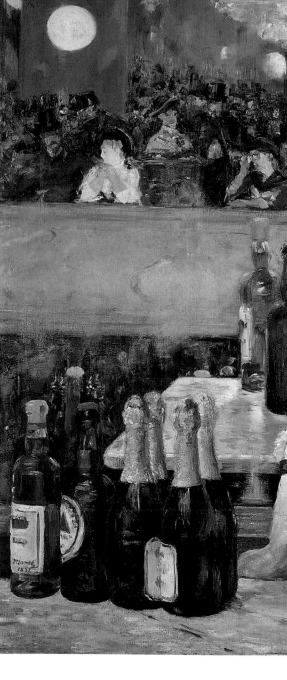

THE JURY FOR THE 1881 Salon included several of Manet's friends. Of 33 jurors present at the honors selection meeting, 17 voted in favor of Manet, and he received a second-class medal. By a majority of only one vote, Manet, at the age of 49, had achieved his lifelong ambition. Although he was now guaranteed acceptance to the yearly Salon, the grudgingly awarded honor came almost too late, and he died just two years later. It is fitting that Manet's final masterpiece should be a scene from modern Parisian life. *A Bar at the Folies-Bergère* was his last Salon work, painted when he was seriously ill in 1882. It was also his last large-scale canvas, the concluding painting in a series of smaller works on café life (pp. 56–57). With this series, Manet returned to the Baudelairian idea of "the heroism of modern life" (pp. 12–13 and 16–17).

WOMEN DRINKING BEER
1878–79; 24 x 23½ in (61 x 60 cm); pastel on canvas
Manet's pastel depicts two of the more "liberated" women who were now to be encountered in the cafés of Paris. Beer was one of the great many alcoholic drinks available in the ever-growing number of cafés – 24,000 by the end of the century.

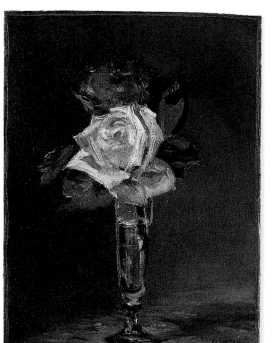

ROSES IN A CHAMPAGNE GLASS
1882; 12¼ x 9½ in (31 x 24 cm)
This painting evolved from the still life of roses in a glass in *A Bar at the Folies-Bergère*, Manet's last major work. His worsening condition meant that he could work only in short bursts at a time and on a smaller scale.

A BAR AT THE FOLIES-BERGERE (STUDY)
1881–82; 18½ x 22 in (47 x 56 cm)
The preliminary study for *A Bar at the Folies-Bergère* was painted in situ and shows a more relaxed, nonchalant barmaid. In the final version (right), using a different design (and different model), Manet opted for a strong personal presence, moving the figure right up to the picture plane in direct confrontation with the viewer. As a result, the viewer takes on the role of customer. Unusually, Manet did not use a professional model but hired the young barmaid, Suzon, from the Folies-Bergère, to pose in his studio where he had set up a mock bar.

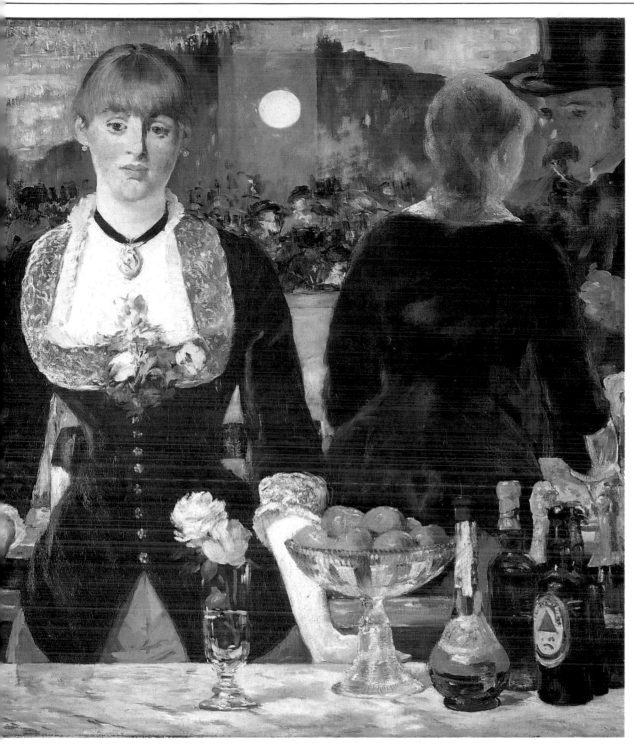

NEW ELECTRIC GLARE
With the painting's silvery, blue-gray tones and the blank white orbs reflected in the mirror, Manet has captured the cool brilliance of electric lighting, then starting to appear in the more exclusive venues.

ACROBAT
In the top left-hand corner of the painting is the bizarre addition of a pair of legs with little green boots and a trapeze. The presence of this acrobat serves to make the distracted barmaid seem all the more dispirited.

INCIDENTAL PORTRAITS
Reflected in the mirror, we can see the busy, animated audience that holds no fascination for the world-weary barmaid. Two of Manet's friends are among the crowd: the woman in white is Méry Laurent (p. 60), and the woman in beige behind her is Jeanne Demarsy. Both "cameos" were painted from portraits Manet had made previously.

MANET'S WORLD
In spite of the barmaid's elusive sadness, this is a joyous work, sparkling with light and color. It is Manet's world, an expression of himself, and it is tempting to see in the barmaid's melancholy Manet's own sadness at his inevitable departure.

A Bar at the Folies-Bergère

1882; 37¾ x 51¼ in (96 x 130 cm)

A young painter, visiting Manet's studio, described him at work on his last masterpiece: "Manet, though painting from life, was in no way copying nature; I noticed his masterly simplifications; the woman's head was being formed, but the image was not produced by the means that nature showed him. All was condensed; the tones were lighter, the colors brighter, the values closer, the shades more diverse. The result was a whole of blond, tender harmony." Manet exhibited the painting at the 1882 Salon, and a month prior to the opening, Paul Alexis, at *Le Reveil*, described "standing at her counter, a beautiful girl, truly alive, truly modern." He wrongly predicted it would be a great success at the Salon.

ODD PERSPECTIVE
Manet was accused of incompetence and lack of understanding of perspective. Critics were astonished by his obvious "mistake": that, since the bar faced the mirror, then the barmaid's customer was "missing." This caricaturist has "repaired the omission" and added the missing figure (right).

Manet's death

MANET'S GRAVE
Manet's tomb was inscribed with a tribute to him by his friend Zacharie Astruc (p. 36).

M ANET DIED OF A DISEASE called *locomotor ataxia* that attacks the central nervous system and causes paralysis. The disease was brought on by untreated syphilis, which Manet may have contracted as early as 1848 (p. 7). By the time of his death, it had reached its tertiary phase. He was 51. Manet's career began relatively late, but he had a precocious talent and developed quickly. What he would have gone on to produce in his later years will, sadly, remain unknown. His last works reveal no deterioration of quality; quite the opposite, and we are cheated of Manet's final phase. It is a telling mark of his generous spirit that toward the end of his life, even when illness forced him to leave his beloved Paris and urbane lifestyle behind to retreat into the country, his paintings continued to reveal unceasing optimism, curiosity, and a love of beauty: the mark of genius.

PHOTOGRAPHIC TRIBUTE
Manet's palette, paint, and brushes have been placed at the front of this tribute to the artist who, in his usual nonchalant fashion, is smoking a cigarette.

A CARING COMPANION
Méry Laurent was Manet's closest woman friend during his last years, and he wrote to her regularly. Renowned for her beauty, style, and generosity, she would send Manet flowers daily during his illness. According to George Moore (p. 37), she annually honored the anniversary of Manet's death by placing lilacs on his grave.

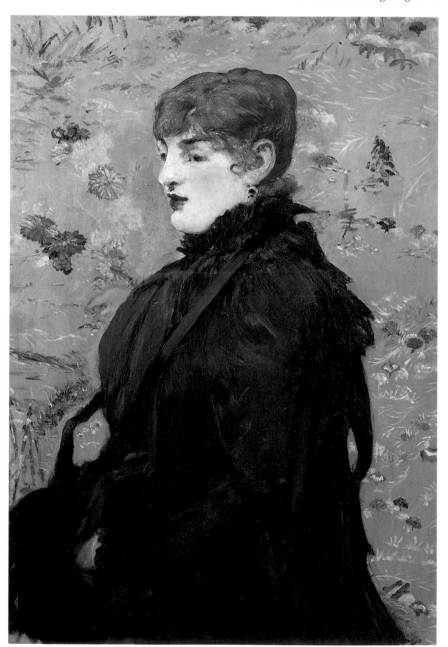

AUTUMN
1882; 28¾ x 20 in (73 x 51 cm)
Manet's love of costume and decoration expressed itself over and over through the innumerable oil and pastel portraits he made of beautiful society women. He chose his friend Méry Laurent to pose for *Autumn* (right), and set off her rich coloring against a dazzling turquoise. She is wearing the fur pelisse over which, according to Proust, Manet was in raptures: "Ah, what a pelisse, my friend, a tawny brown with old-gold lining. I was stunned ... she has promised it to me. It will make a splendid backdrop for some things I have in mind." His love for women's fashions was well known, and his enthusiasm was shared with Mallarmé, who sometimes wrote under the pseudonym "Miss Satin."

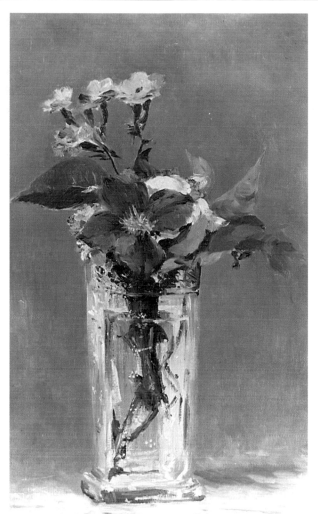

PINKS AND CLEMATIS IN A CRYSTAL VASE

1883; 22 x 13¾ in (56 x 35 cm)

According to Tabarant, this was one of Manet's last works, part of a series of small flower paintings he produced in his few remaining months of life. This may be inaccurate, but what is certain is the brilliance of these small masterpieces. Uniformly stunning, they are full of the life and gaiety of Paris that, being confined to the country, he so missed. The square-based crystal vase, decorated with tiny flowers, was one that Manet painted many times. Indeed, in most of his flower paintings he chose clear vases that revealed the stems and submerged leaves of the flowers. In this painting, the small handful of garden flowers appear to have been dropped straight into water, their stems still tied, giving an air of naiveté to the work. Manet's paintings of fruit and flowers are among his least contrived works, and reveal a surprising, almost childlike wonder.

A PAINFUL DEATH

For the last six months of his life, Manet endured almost constant pain. In March 1883 gangrene had developed in his left foot, and there was no option but to amputate. The operation was performed at his home on April 19, and he died, after great suffering, 11 days later.

FUNERAL BOOK

Antonin Proust (p. 6) was a speaker at Manet's funeral on May 5, 1883, and Claude Monet (p. 52) and Emile Zola (p. 28) were pallbearers. The funeral book (left) contains signatures of those who attended, and is a record of a gathering of some of France's greatest names. This page alone was signed by the painters Pissarro, Boudin, Raffael, Sisley, Renoir, and the critic Paul Alexis.

Signatures of mourners at Manet's funeral

Fund-raising letter from Monet

MONET'S GESTURE

After Manet's death there was a move to secure a permanent home for *Olympia* (pp. 28–29) in the Louvre, organized by Monet. He was instrumental in raising, from Manet's friends and supporters, the amount needed to purchase *Olympia* from Manet's widow – motivated, perhaps, by gratitude to Manet for his help and support during Monet's difficult years.

THE DEBATE CONTINUES

When Manet's *Olympia* (pp. 28–29) was finally accepted by the Louvre in 1893 (30 years after it was painted), the *Journal Amusant* sent out this questionnaire (left) to its readers, asking their opinion on the matter. There were many replies, of which this short example (above), declaring the very idea to be scandalous, was typical – reflecting Manet's ability, even in death, to provoke controversy.

Key biographical dates

1832 Edouard Manet born in Paris, January 23.

1844 Enters the Collège Rollin. Meets Antonin Proust.

1848 Fails entrance exam to naval college. Sails to Rio de Janeiro on the training ship *Le Havre et Guadeloupe*.

1849 Stays in Rio de Janeiro for two months, then returns to Paris.

1850 Enters Thomas Couture's studio. Registers as copyist in the Louvre.

1852 Birth of Léon-Edouard Leenhoff, son of Suzanne.

1853 Travels to Dresden, Prague, Vienna, Munich, Normandy, Venice, Florence, and Rome.

1855 Visits Eugène Delacroix at his studio in the rue Notre-Dame-de-Lorette.

1856 Leaves Couture's studio; sets up studio in the rue Lavoisier with the painter Albert, Comte de Balleroy. Visits Rijksmuseum in Amsterdam.

1857 Meets Henri Fantin-Latour at the Louvre. Travels to Italy.

1858 Meets Charles Baudelaire.

1859 *The Absinthe Drinker* is turned down by the Salon. Moves to new studio in the rue de la Victoire.

1860 Moves with Suzanne and Léon to an apartment in the Batignolles.

1861 *Portrait of M. and Mme. Manet* and *The Spanish Singer* shown at the Salon. *The Spanish Singer* receives honorable mention.

1862 Death of Auguste Manet, Edouard's father. Paints *Music in the Tuileries*. Meets Victorine Meurent.

1863 Shows *Déjeuner sur l'Herbe* at the Salon des Refusés. Manet marries Suzanne Leenhoff in Zalt-Bommel, Holland.

1864 Exhibits *Episode from a Bullfight* at the Salon.

1865 *Olympia* creates an uproar when shown at the Salon. Visits Spain.

1866 *The Fifer* and *The Tragic Actor* rejected by the Salon. Meets Cézanne and Monet. Frequents Café Guerbois.

1867 Holds major retrospective exhibition alongside the Exposition Universelle. Paints first version of *The Execution of Emperor Maximilian*.

1868 Meets Berthe Morisot. Paints *Portrait of Emile Zola*.

1869 Eva Gonzalès becomes Manet's pupil and model. Exhibits *The Balcony* at the Salon, but *The Execution of Emperor Maximilian* (final version) is banned.

1870 Franco-Prussian war. Manet joins the National Guard.

1871 Elected to the artists' committee of the Paris Commune.

1873 *Le Bon Bock* shown at the Salon. Meets Stéphane Mallarmé.

1874 Offered the chance to exhibit at the first Impressionist exhibition, but refuses. Eugène Manet marries Berthe Morisot. Edouard spends the summer painting alongside Monet at Argenteuil.

1875 Shows *The Seine at Argenteuil* at the Salon. Travels to Venice.

1876 Paints *Portrait of Stéphane Mallarmé*.

1877 *Nana* rejected by the Salon.

1878 Paints *Self-Portrait with Skull Cap*.

1880 Paints *Portrait of Antonin Proust*, which is then shown at the Salon.

1881 Antonin Proust becomes Minister of Fine Arts. Manet is awarded a second-class Legion of Honor medal.

1882 Health worsens. *A Bar at the Folies-Bergère* is exhibited at the Salon.

1883 Left leg amputated April 19. Dies April 30.

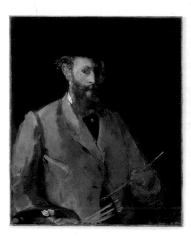

SELF-PORTRAIT WITH PALETTE
c.1879; 32¼ x 26¼ in (83 x 67 cm)

Manet collections around the world

The following shows the locations of museums and galleries around the world that own three or more paintings by Manet.

USA
Boston Museum of Fine Arts
Cambridge, MA Fogg Art Museum
Chicago The Art Institute of Chicago
Cleveland, OH Museum of Art
Merion, PA Barnes Foundation
New York Metropolitan Museum of Art; Guggenheim Museum
Pasadena, CA Norton Simon Foundation
Philadelphia Museum of Art
San Francisco San Francisco Art Museums
Shelburne, VT Shelburne Museum
Williamstown, MA Clark Art Institute
Washington, DC National Gallery of Art

SOUTH AMERICA
Brazil
São Paulo Museu de Arte

EUROPE
Denmark
Copenhagen Ny Carlsberg Glyptotek
France
Paris Musée d'Orsay
Lyon Musée des Beaux-Arts
Germany
Berlin Neve Nationalgalerie
Hamburg Kunsthalle
Munich Neue Pinakothek
Norway
Oslo Nasjonalgalleriet
Switzerland
Zürich Bührle Foundation
Winterthur Oskar Reinhart Collection
UK
Glasgow Glasgow Museums and Art Galleries – The Burrell Collection
Cardiff National Museum of Wales
London Courtauld Institute Galleries; National Gallery

ASIA
Japan
Tokyo Bridgestone Museum of Art

AUSTRALASIA
Melbourne National Gallery of Victoria

Glossary

Academic art Art that conformed to the standards of the French Academy, the official body that promoted traditional art based on classical ideals.

Broken color Unmixed paint that is applied in mosaic-like patches, or dragged across a rough canvas or underpaint so that it is covers it irregularly.

Complementary colors Two colors are "complementary" if they combine to complete the spectrum. So the complementary of each primary color – red, blue, and yellow – is the combination of the other two. Red and green; blue and orange; and yellow and violet are the basic pairs. In painting, placing complementary colors next to each other makes both appear brighter.

Ebauche The preparatory work on the canvas of what is intended to be a completed painting, giving the work a base in color and tone.

En plein air (French: "In the open air.") Painting outdoors.

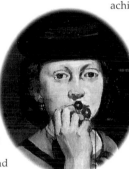
Impasto

Flat color An unmodeled area of color – an evenly applied, unvaried expanse of red, for example.

History painting Paintings depicting historical, literary, legendary or Biblical scenes, intended to be morally uplifting. Considered by the Academics to be the highest form of painting

Hue The attribute of a color that enables an observer to classify it as red, blue, etc., and excludes white, black, and gray.

Illusionism The use of techniques such as perspective to deceive the eye into taking the painted image for that which is real.

Impasto Paint applied in thick, raised strokes.

Medium In paint, the vehicle (substance) that binds the pigment – for instance, in oil paint the medium is an oil (poppy oil, etc.), in tempera the medium is egg.

Motif The dominant or recurring subject of a painting.

Naturalism Art that represents objects as they are observed.

Palette Both the flat surface on which an artist sets out and mixes paints, and the range of pigments used in painting.

Pastel A stick of powdered pigment mixed with just enough gum to bind the particles. (Also the name for a work of art using pastel.)

Peinture claire (French: "Painting light.") Painting with high-keyed tones to suggest bright, outdoor light.

Realism The French art movement, led by Gustave Courbet, that rejected the academic tradition in favor of unidealized paintings of ordinary people and objects.

Salon The official art exhibition in Paris, first established in 1667 by the French Academy and usually held annually.

Peinture claire

Still life A painting of inanimate objects such as flowers or fruit.

Trompe l'oeil (French: "trick of the eye.") A painting containing elements within it which deceive the eye and the mind as to the material reality of a particular object.

Ukiyo-e (Japanese: "Pictures of the floating world.") A movement of 16th- and 17th-century Japanese painting and printmaking that depicted contemporary scenes.

Vanitas Type of still-life painting that flourished in the Netherlands in the early 17th century. Subjects were usually collections of objects symbolic of the inevitability of death and the vanity of earthly achievements and pleasures.

Woodcut Relief print made from cutting into a design drawn on wood with a knife, gouge, or chisel. The raised surface is inked and printed on paper, using pressure by hand or in a press.

Manet works on exhibit

Index

Acknowledgments

PICTURE CREDITS

Every effort has been made to trace the copyright holders and we apologize in advance for any unintentional omissions. We would be pleased to insert the appropriate acknowledgement in any subsequent edition of this publication.

Key:
t: top *b:* bottom *c:* center *l:* left *r:* right

Abbreviations:
AIC: © The Art Institute of Chicago, All Rights Reserved; ATP: Musée des Arts et Traditions Populaires, Paris; BAA: Société des Amis de la Bibliothèque d'Art et d'Archéologie, Paris; BM: Trustees of the British Museum, London; CG: Courtauld Institute Galleries, London; FAB: Museum of Fine Arts, Boston; MET: Metropolitan Museum of Art, New York; MM: Musée Marmottan, Paris; MO: Musée d'Orsay, Paris; NG: Reproduced by courtesy of the Trustees, The National Gallery, London; NGW: © National Gallery of Art, Washington; PC: Private Collection; PM: David A. Loggie, The Pierpont Morgan Library, New York; PVP: Phothothèque des Musées de la Ville de Paris; RMN: Réunion des Musées Nationaux, Paris; VL: Visual Arts Library, London

p1: BN **p2:** *tl:* PM; *tr:* MO; *cl:* BN; *c:* Wildenstein Galleries, New York; *cr:* Musée de la Publicité, Paris, all rights reserved; *b:* NG; *br:* Collections Royal Army Museum, Brussels, Db (a) 13981 **p3:** *c:* PC; *c:* Gift of Richard C. Paine in memory of his father, Robert Treat Paine II, courtesy of FAB; *bl:* PM; *br:* PC/Giraudon, Paris **p4:** *tl:* PC; *tc:* BN; *tr:* PM; *cl:* New Orleans Museum of Art/VL; *cr:* BM; *bl:* Collection of Mr. and Mrs. Paul Mellon © 1992 NGW; *bc:* thanks to Dominique Ronot; *br:* ATP *c:* photo: RMN **p5:** *br:* MO **p6:** *tr:* PC; *c:* Statens Konstmuseer, Stockholm; *bl:* BN; *br:* Isabella Stewart Gardner Museum, Boston **p7:** *tl:* Reynolds Museum,

Winston Salem, North Carolina/Bridgeman Art Library, London; *tr:* photo: Mark Sexton **p7:** *cr:* PC; *b:* The Hulton Deutsch Collection **p8:** *tl:* ATP © photo: RMN; *cl:* Louvre, Paris/RMN; *bl:* Musée Carnavalet/PVP © DACS 1993; *br:* Kent Fine Art, New York/Philippa Thomson, London **pp8–9:** *c:* Musée des Beaux-Arts, Lyon **p10:** *tl:* BN; *tr:* Ackland Art Museum, The University of North Carolina at Chapel Hill, The William A. Whitaker Foundation Art Fund **pp10–11:** *c:* MO **p11:** *tl:* BN; *tr:* © The Detroit Institute of Arts, gift of Mr. and Mrs. Edward E. Rothman; *br:* BAA **p12:** *tl:* BN; *bl:* Chester Dale Collection © 1992 NGW; *tr, cr:* ATP; *br:* MO **p13** *cl:* ATP; *r:* NY Carlsberg Glyptotek, Copenhagen **p14:** *cl:* Ville de Paris, Service Technique de la Documentation Foncière; *bl:* PVP © DACS 1993; *tr:* BN; *br:* BN **p15:** *tl:* MO/VL; *tr:* Collection Union Française des Arts du Costume, Paris; *cl:* Stickney Fund 1905.207, AIC; *bl:* Gulbenkian Foundation, Lisbon **pp16–17:** NG **p18:** *tl:* BN; *bl:* Wildenstein Galleries, New York; *tr:* MET, gift of William Church Osborn, 1949 (49.58.2); *br:* Musée de la Publicité, Paris **p19:** *tl:* BAA; *tr:* MO; *cl:* BN ; *cr:* BAA; *b:* Widener Collection © 1992 NGW **p20:** *cl:* Gift of Richard C. Paine in Memory of his father, Robert Treat Paine II, courtesy of FAB; *bl:* PM; *tr:* MET, gift of Erwin Davis, 1889 (89.21.3), photo by Malcolm Varon. PM **p21:** *l:* Bequest of Sarah Choate Sears in memory of her husband, Joshua Montgomery Sears, courtesy of FAB; *cr:* Hulton Deutsch Collection Ltd **p22:** *tl:* BN; *tr:* Petit Palais/PVP © DACS 1993; *cl:* BAA; *b:* © Collection Viollet **p23:** *tc:* © N.D. – Viollet; *tr:* PM; *cl:* Metropolitan Museum of Art, bequest of Mrs. H.O. Havemeyer 1929, H.O. Havemeyer Collection (29.100.53); *cr:* PM; *br:* Harris Whittemore Collection, NGW **p24:** *cr:* Louvre, Paris/© Photo RMN; *cl:* BN; *br:* CG **pp24–25:** MO **p25:** *bl:* Musée Carnavalet/PVP/© DACS 1993; *br:* MO **p26:** *tl, tr, cl:* BN; *bl:* Zalt-Bommel, Holland; *br:* Museo Nacional de Bellas Artes, Buenos Aires **p27:** *tl:* MO; *tr:* BN; *cl:* MO/VL; *bc:* MO; *br:* Kitakyushu Municipal Museum of Art, Japan **p28:** *tr:* Giraudon, Paris **pp28–29:** *c:* MO **p29:** *tl:* Uffizi, Florence/Scala; *tr:* BN; *cr:* MO; *br:* BAA **pp32–33:** *bc:* Mr. and Mrs. Lewis Larned Coburn Memorial Collection, 1942.311, AIC **p33:** *tl:* Wallraf-Richartz Museum/Rheinisches Bildarchiv, Cologne; *tr:* MO; *bc:* MO; *c:* Glasgow Museums and Art Galleries – Burrell Collection; *br:* MO **p34:** *tl:* BM; *c:* Gift of Mrs John W. Simpson, NGW; *bl:* Gulbenkian Foundation, Lisbon;

br: NG **p35:** MO **p36:** *tl:* © Museo del Prado, Madrid, all rights reserved; *tr:* Museo del Prado, Madrid/VL; *br:* Mr. and Mrs. Martin A. Ryerson Collection, 1937.1019, AIC; *bl:* © N.D. – Viollet; *bc:* Gift of Edith Stuyvesant Gerry, NGW **p37:** *tl:* MO; *bl:* Bibliothèque Littéraire Jacques Doucet, Paris; *br:* MO **p38:** *tl:* The Norton Simon Foundation; *tr:* Musée . Carnavalet/PVP © DACS 1993; *cr:* A.A. Munger Collection, 1910.304, AIC **p39:** *tl:* Arthur Jerome Eddy Memorial Collection, 1931.504, AIC; *bl:* BN; *cr:* NY Carlsberg Glyptotek, Copenhagen; *br:* © Museo del Prado, Madrid, all rights reserved **pp40–41:** MO **p42:** *tl:* Gift of Mr. and Mrs. Frank Gair Macomber, courtesy FAB; *cl:* © Museo del Prado, Madrid, all rights reserved; *bl:* Städtische Kunsthalle, Munich; *bc:* Collections Royal Army Museum, Brussels Db (a) 13981 **p43:** *tl:* NG; *bl:* Collections Royal Army Museum, Brussels Db (b) 10228; *br:* BN **p44:** *tl:* BN; *cl:* AIC/VL; *cr:* PM; *br:* Musée Carnavalet/PVP © DACS 1993 **p45:** *tl, bl:* Reproduced by courtesy of the Board of Directors of the Budapest Museum of Fine Arts; *cr:* BAA **p46:** *tl:* MET/MAS; *bl, tr, cr, br:* PC **p47:** MO; *tr:* BAA; *br:* Jean-Loup Charmet **p48:** *bl:* MO; *tr:* BAA; *br:* Staatliche Museen zu Berlin – Preussischer Kulturbesitz Nationalgalerie, photo: Jörg P. Anders, Berlin; *br:* Walters Art Gallery/Visual Arts **p49** *tl:* Toledo Museum of Art, Toledo, Ohio; purchased with funds from the Libbey Endowment; gift of Edward Drummond Libbey; *tr:* BN; *br:* PM **p50:** *tl:* BAA; *bl:* NG; *bc:* BAA; *br:* Rijksmuseum, Amsterdam; *br:* BN **p51:** Philadelphia Museum of Art: Mr. and Mrs. Carroll S. Tyson Collection; *br:* BAA **p52:** *tl:* PVP © DACS 1993; *cr:* MM; *bl:* Neue Pinakothek, Munich; *br:* MM; **p53:** *tl:* Bridgestone Museum of Art, Ishibashi Foundation, Tokyo; *tr:* BAA; *cr:* BN; *bc:* MO; *br:* BAA **p54:** *br:* PC **pp54–55:** CG (Courtauld Collection) **p56:** *tl:* BN; *tr:* New Orleans Museum of Art/VL; *cl:* Musée de la Publicité, Paris; *c:* BAA, Paris; *bl:* PM; *br:* Hamburger Kunsthalle, Hamburg **p57:** Collection of Mr. and Mrs. Paul Mellon, © 1992 NGW; *tr:* MO; *c:* BN; *cl:* thanks to Dominique Ronot; *bc:* Sammlung Oskar Reinhart "Am Römerholz", Winterthur; *br:* NG **p58:** *c, bl:* Glasgow Museums and Art Galleries – Burrell Collection; *bc:* PC/VL **pp58–59:** CG (Courtauld Collection) **p59:** *br:* BN **p60:** *tl:* PC; *tr:* BN; *c:* Bibliothèque Jacques Doucet, Paris; *br:* Musée des Beaux-arts, Nancy/© Gilbert Mangin **p61** *tl:* MO; *tr, bl, bc, br:* BAA; *c:* PM **Front cover:** Clockwise from top left: BM; BAA; MO; PC; PC; MO; Wildenstein

Galleries, New York; DK; MO; *c:* BN Back cover: PC; © Collection Viollet; MO; ATP/RMN; *White Peonies and Secateur* (detail), MO (also *c, cl*); PC; BN; NY Carlsberg Glyptotek, Copenhagen; ATP **Inside front flap:** *t:* BN; *b:* MO.

Additional Photography
Philippe Sebert: **p2:** *tr;* **p3:** *cl;* **p4:** *tl;* **p5:** *br;* **p6:** *tr;* **p7:** *cr;* **pp10–11:** *c;* **p12:** *tr, c;* **p13:** *cl;* **pp24–25:** *p25;* **br;* **p27:** *tl, bc;* **pp28–29:** *c;* **p29:** *tr;* **pp30–31:** *p32:** *bl;* **p33:** *tr, br;* **p35;* **p37:** *tl;* **p46:** *br;* **p49:** *br;* **p53:** *bc;* **p54:** *tl;* **p57:** *tr;* **p60:** *tl;* **p61:** *tl;* Alison Harris: **bc;* **p6:** *tl;* **p51:** *bl;* Andy Crawford: **front cover:** *cl;* **p14:** *tl;* **p15:** *tr;* **p20:** *tl;* **p40:** *tl;* Guy Ryecart: **p3:** *cr;* **p32:** *tl.*

Dorling Kindersley would like to thank:
Joanna Figg Latham for DTP assistance; Mme. Sevin at the Bibliothèque d'art et d'archaeologie; special thanks to M. Chapon, Conservateur en Chef at the Bibliothèque Litéraire Jacques Doucet; the staff at the Musée d'Orsay, Paris; Jacques Deville at the Bibliothèque Nationale, Paris; Hilary Bird for the index.

Author's acknowledgements:
I would like to thank John Leighton and Emma Shackleton at the National Gallery, London, for their help and advice; Juliet Wilson-Bareau and Rosalind de Boland Roberts for providing much needed information. I would especially like to thank all those at Dorling Kindersley who contributed to this book, in particular the editor, Phil Hunt, and designer, Mark Johnson-Davies, Gwen Edmonds, and Toni Kay, Helen Castle, and Jo Evans, with special thanks to Julia Harris-Voss for her energy and enthusiasm. Above all my thanks to Sean for all his patience and support.